IMAGES
of America

CARMICHAEL

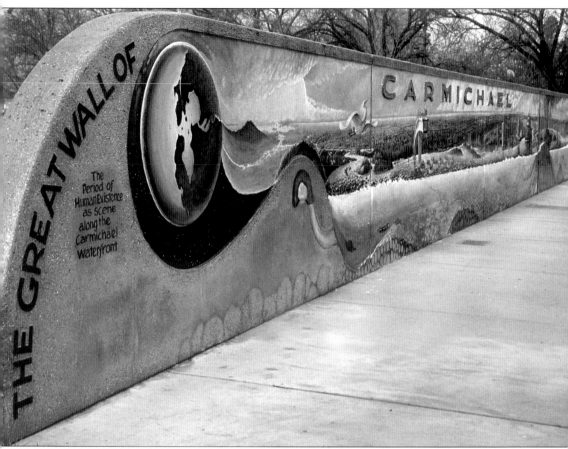

"The Great Wall of Carmichael" graphically represents the history of Carmichael and the surrounding region, from Indian petroglyphs to the present. The 100-foot mural by artist Hugh Gorman depicts history so authentically that it was awarded a "Heritage through Art" trophy in 2003, the year after the mural was completed. The American River is prominent in the mural, replete with leaping salmon and splashing Native American children. Gorman's thorough research into the history of Carmichael is evident and worth careful study. The Great Wall is located at the corner of Fair Oaks Boulevard and Grant Avenue in Carmichael Park. (Photograph by Noel Neuburger; courtesy of Hugh Gorman.)

IMAGES
of America

CARMICHAEL

Kay Muther

ARCADIA

Copyright © 2004 by Kay Muther
ISBN 0-7385-2911-7

Published by Arcadia Publishing
Charleston SC, Chicago IL, Portsmouth NH, San Francisco CA

Printed in Great Britain

Library of Congress Catalog Card Number: 2004106566

For all general information contact Arcadia Publishing at:
Telephone 843-853-2070
Fax 843-853-0044
E-mail sales@arcadiapublishing.com
For customer service and orders:
Toll-Free 1-888-313-2665

Visit us on the internet at http://www.arcadiapublishing.com

CONTENTS

ACKNOWLEDGMENTS

This illustrated history of Carmichael, California, began with a little note in Walt Wiley's column for the *Sacramento Bee* in December 2003, in which he announced that Arcadia was looking for authors to tell the story of some of Sacramento County's neighborhoods. I stepped up to volunteer and the rest, as they say, is history.

Several of the wonderful people I worked with deserve special recognition: A.L. "Red" Hughes for providing me with photos, including our wonderful cover, plus a list of the names of the class representatives of the San Juan Alumni Association; Dorothy Dickson St. John, who had some great pictures as well as some good ideas about who else to contact; and Doris Graves Chez, whose collection of photographs and genealogical material is very impressive. Many other people opened their homes and photo albums to me and I am very grateful.

I referred to *A History of the Carmichael School and Community, 1880 to 1960* by James R. Cowan to check my facts and to fill in some gaps. It was very helpful.

I apologize for any errors, inaccuracies, or omissions in this book, and I take full responsibility for them.

—Kay Muther

INTRODUCTION

The rolling hills, covered with lush grass and oak trees, stretched along the north side of the American River in 1909 when Daniel W. Carmichael bought the first 2,000 acres. He called it Carmichael Colony No. 1 and offered it for sale in 10-acre lots. The terms were $1,500 each with 10 percent down and payments of $10 a month. Advertising appeared in area newspapers and in the national press, including *Sunset Magazine*.

The colony was part of a much larger Mexican land grant known as Rancho San Juan, which was only sparsely settled. The original inhabitants were Native Americans, probably Maidu Indians. For many years, an old sweat house near Walnut Avenue and Winding Way reminded settlers of the area's Indian beginnings. White families began farming nearby around 1860, but it was much later before serious growth occurred.

In 1911 Carmichael purchased an additional 1,000 acres to the west of Carmichael Colony No. 1. Colony No. 2 had originally been part of the 44,000-acre Mexican land granted to Eliab Grimes in 1844. Before Carmichael acquired it, horseman James Ben Ali Haggin and his associates raised racehorses there.

Mary A. and Charles Deterding were the first permanent settlers in the colony area, establishing their 400-acre ranch, known as San Juan Meadows, on the west side of the American River in 1907. Originally planted in alfalfa, the ranch developed substantial orchards of pears, peaches, and plums.

On the higher ground above San Juan Meadows, people purchased parcels of land and tried to plant orchards. Unfortunately, the brick-like layer of soil known as "hard pan" hindered digging holes large enough for the young trees. Dynamite blasts echoed around the colony as farmers struggled to develop their orchards. Persistence paid off, and by 1927 there were about 300 families making a living in Carmichael, many of them farmers, orchardists, or dairymen.

Businesses grew up alongside what was then called H Street, now Fair Oaks Boulevard. Roadside stands offered summer fruits, vegetables, and eggs. In the 1920s the Arrowhead Store and the Williams Family Grocery provided many of the local consumers' needs. With the appearance of cars and tractors, service stations and garages were needed. The Triangle Service Station, Clark's Garage, and the Sunnydale Garage (owned and operated by Glenn Hughes) helped meet that need. Other stores were added, but it wasn't until 1963 that a major shopping center, Crestview Center, was built at the corner of Manzanita and Winding Way.

Education was another real community need. The earliest school was San Juan Elementary near the corner of Dewey Drive and Winding Way. Families began demanding a bigger, better

school, and Dan Carmichael agreed to donate 10 acres to that cause as long as the resulting school would be named after him. It was and still is. Carmichael School is located on Sutter Avenue at California Avenue and is still in use today. More schools were built as the growing population demanded them. Today those schools are part of the San Juan School District, one of the finest school districts in Northern California.

Church services were held in the Carmichael School until a group raised the money to build the Carmichael Community Church in 1927. Now affiliated with the Presbyterian Church, it was a central focus of community life from its creation. The next church was a more conservative offshoot that split from the Community Church. It was first called Wayside Chapel and later became the Carmichael Bible Church. Over the years, other denominations built churches, and today a wide range of worship is available to Carmichael residents.

Community organizations were active from the very early years. The Carmichael Improvement Club, the Carmichael Irrigation District, and the Carmichael Utility District were citizen-formed groups that resulted in phone service, electricity, paved streets, controlled water distribution, better community facilities, improved schools, and even library services. There has always been a solid feeling of community in Carmichael. One of the old settlers was heard to say, "Carmichael, it was a great place to live." It still is.

One

Settlers and
Later Families

The first settlers in this area were Maidu Indians. We know they settled here because they left behind remnants of their culture, such as arrowheads, pottery, and even an old sweat house that coexisted with the farmers for many years. Spanish explorers may have passed through the area in the 18th century, and perhaps some fur trappers did so as well in the early 19th century. In the 1850s there were trails from Sacramento to the gold fields although the main gold rush traffic was south of the American River.

Two Mexican land grants accounted for much of the land north of the American River and east of the Sacramento River. The two shared a common boundary that went through what became the heart of Carmichael. Some settlers lived closer to Auburn Road, but there were few on the lower part of the grants. Not until Daniel W. Carmichael bought 2,000 acres for Carmichael Colony No.1 in 1909 did significant growth begin.

"Lots for sale in Carmichael, California—10 acre tracts for $1,500 with 10 percent down on terms of $10 a month at 6 percent interest." Ads like this ran in newspapers across the country. The claim was that a farmer could be self-sufficient and make enough profit to pay off his land in just a few years. Midwesterners who were tired of the cold winters read about California and decided to come. Service industries sprang up. Some folks began commuting to Sacramento from Carmichael, setting a pattern followed to this day.

But whatever their occupations, those who settled in Carmichael were family people with family values. The stories of some of these families and their descendants are told in the following pictures.

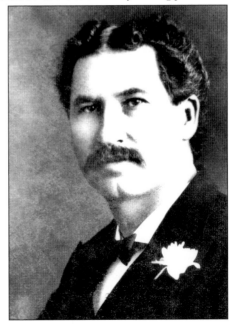

Daniel W. Carmichael, born in Atlanta, Georgia, in 1867, moved to California in 1885. In 1895 he formed the real estate firm of Curtis, Carmichael, and Brand, a business devoted to the acquisition and development of the Sacramento Valley. In 1909 he purchased land for Carmichael Colony No. 1, then added 1,000 acres to his holdings in 1911 for Colony No. 2. Carmichael served as mayor of Sacramento from 1917 to 1919. While he never actually lived in Carmichael, he greatly influenced its development. (Courtesy of Carmichael Chamber of Commerce.)

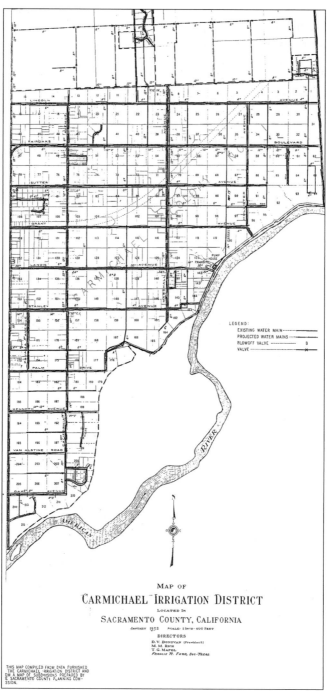

MAP OF
CARMICHAEL IRRIGATION DISTRICT
LOCATED IN
SACRAMENTO COUNTY, CALIFORNIA
January 1932 Scale: 1 inch = 400 Feet
DIRECTORS
D. V. DONOVAN (President)
M. M. RICH
T. G. MAPEL
FRANCIS R. FORD, Sec-Treas.

This is a map of Carmichael Colony No. 1. The western boundary is Fair Oaks Boulevard (then known as H Street) and its continuation, Manzanita Drive. The southern and part of the eastern boundary is the American River. San Juan Avenue makes up the rest of the eastern boundary. The northern boundary lies just north of Lincoln Avenue. These 2,000 acres were offered in 10-acre parcels, but many families bought more than one parcel. (Courtesy of Elsie Gibbons Cosans.)

This is a map of Carmichael Colony No. 2, which extended Carmichael west to Walnut Avenue but went north only as far as North Avenue in the original 1,000-acre purchase. Again, parcels were offered in 10-acre lots. (Courtesy of Elsie Gibbons Cousans.)

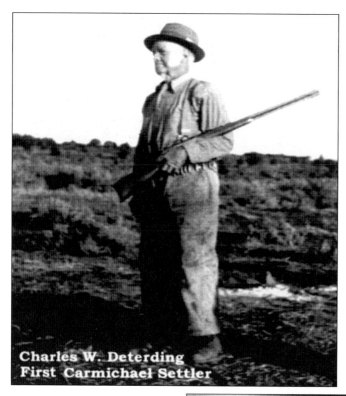

Charles W. Deterding
First Carmichael Settler

Charles W. Deterding was born in 1857 to parents who emigrated to California in 1851 in a covered wagon. The senior Mr. Deterding tried several occupations before buying 520 acres of land that he farmed and used as a base for a hotel along the Sacramento to Virginia City, Nevada route. Charles followed in his father's footsteps by farming 425 acres on the north side of the American River. (Courtesy of Russell Deterding.)

Mary A. Shields, born in 1860, grew up on a farm planted in grapes and other fruit near Mills Station. She married Charles Deterding in 1884, moved to San Juan Meadows, and had three children. Mary Deterding was one of the original activists, promoting education and other services for Carmichael. She was the founder and first president of the Carmichael Improvement Club and was instrumental in the establishment of the Carmichael Irrigation District and the Carmichael Utility District. Her active involvement in community affairs continued until her death in 1940. (Courtesy of Russell Deterding.)

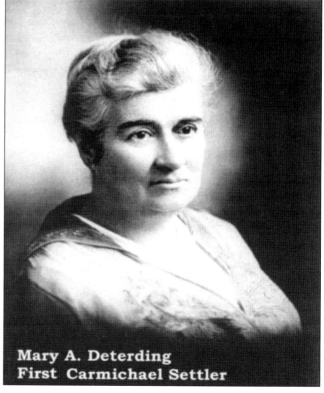

Mary A. Deterding
First Carmichael Settler

Charles W. Deterding Jr., son of Charles and Mary Deterding, was born in 1885. He was an engineer and bridge builder and served as Sacramento County's first county executive. (Courtesy of Russell Deterding.)

J.R. "Dick" Deterding, born in 1889, was the youngest child of Charles and Mary Deterding. He continued to run cattle on the San Juan Meadow ranch as well as own and operate a wholesale plumbing supply store. (Courtesy of Russell Deterding.)

Mary Margaret Deterding followed the example set by her grandmother Mary. Born in 1925, she was well known for her philanthropic endeavors, and throughout her life she helped shape education, health care, children's services, and many other cultural causes. (Courtesy of Russell Deterding.)

Fred E. Graves, born in 1861 in South Dakota, emigrated to Carmichael in 1913 with his wife and children. According to a letter he wrote to his brother back home in 1914, Fred considered this area "the most beautiful country I ever saw or ever expected to see." He was in the process of planting an orchard on his 100 acres when he was killed in a blasting accident in 1916. (Courtesy of Doris Graves Chez.)

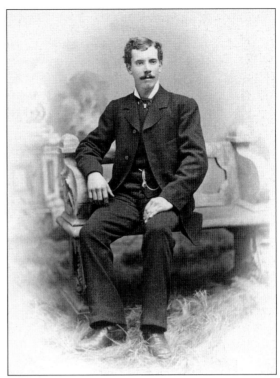

Clara May Todd Graves lived in Carmichael for a couple of years after the death of her husband, Fred. Her two older children, Bernard and Bayard, took over part of their father's original holdings when Clara moved to Sacramento to take a job with the Black Package Store. (Courtesy of Doris Graves Chez.)

Clara Graves is shown here with her two younger children, Faye and Fern. This trio moved to Sacramento when Faye was old enough to enter high school. (Courtesy of Doris Graves Chez.)

Clara Graves (far left) is flanked by Em and Will Lanam, Anna Graves (Bernard's wife), and Bayard Graves. In the front row, Faye is on the left, then Fern. One of Bernard's sons is the little guy in the front, *c*. 1918. (Courtesy of Doris Graves Chez.)

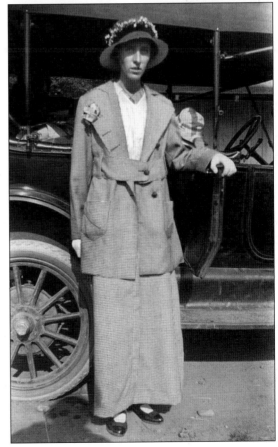

Anna Graves is shown standing in front of the family automobile, probably on the same day as the above picture considering that her dress is the same. (Courtesy of Doris Graves Chez.)

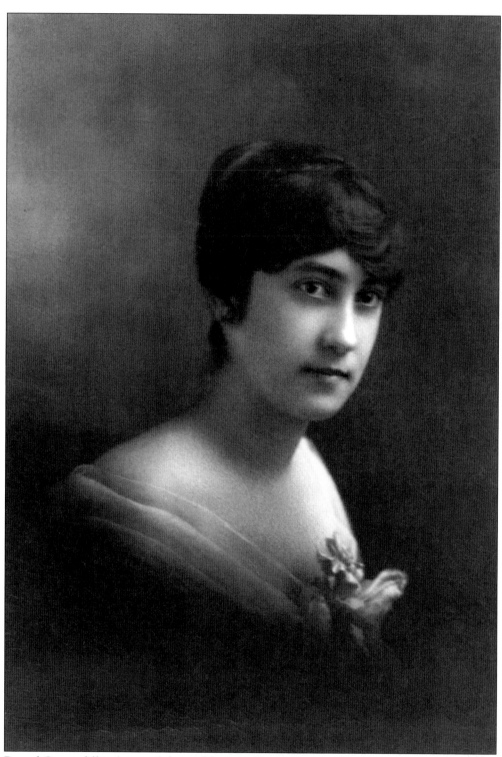

Bayard Graves fell in love with beautiful young Elsie Hartman, shown here in her late teens around 1916. The pair married on December 17, 1921. (Courtesy of Doris Graves Chez.)

18

Elsie Hartman and her brothers Amon, about 13, and Art, age 24, pose for a group photo in 1917 as Art is preparing to join the army. (Courtesy of Doris Graves Chez.)

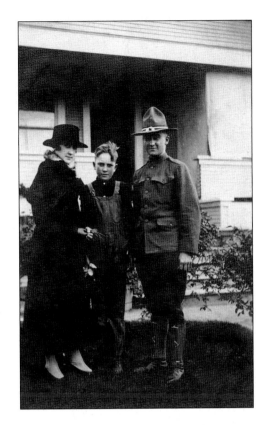

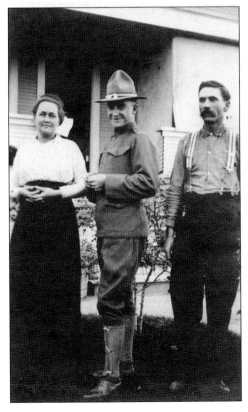

Elsie's parents, Mary Jane and Henry Hartman, stand on either side of Art in this photo from 1917. (Courtesy of Doris Graves Chez.)

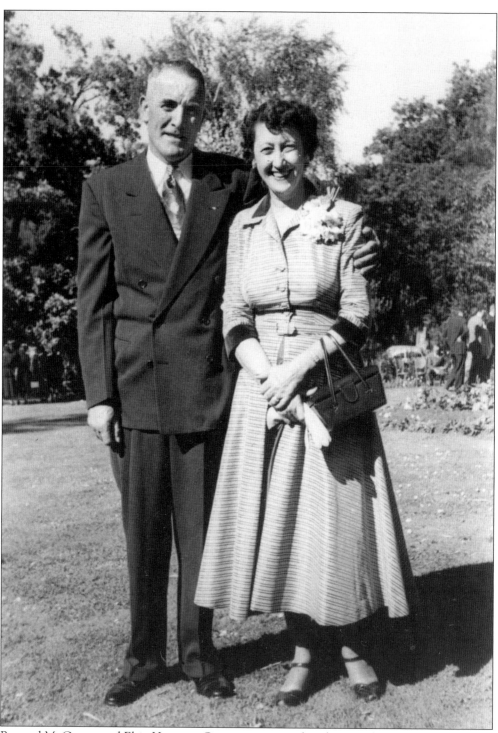

Bernard M. Graves and Elsie Hartman Graves are pictured at the age of 55 in Palo Alto where they were attending the graduation of their daughter Doris from Stanford University. (Courtesy of Doris Graves Chez.)

Susan Lena Marsac Cowan, born in 1879, married William V. Cowan in 1903. By the time they moved to Carmichael in 1916, they had seven children, while one more was born in 1918 at the new farmhouse. Mrs. Cowan was one of the founders of the Carmichael Parent Teachers Association and was a fine pianist. In 1926 it became necessary for her to support her family, so she went to work for the Department of Motor Vehicles. (Courtesy of Jim Cowan.)

The eight children of William and Lena Cowan shown here, from left to right, are (front row) John, James, and William; (back row) Pauline, holding Elizabeth, Janet, Virgil, and Margaret. This 1919 photo was taken in front of the family's 20-acre farm on the northwest corner of Marconi Avenue and Garfield Avenue. (Courtesy of Jim Cowan.)

James "Jim" Cowan is shown here in what is probably his high school graduation picture, c. 1934. He became a school teacher and then a principal and superintendent, retiring from the San Juan School Unified School District to take up farming in Amador County. (Courtesy of Linda Morrison.)

Lena Cowan, as she appeared later in life, didn't show the wear and tear that eight children must have exacted. All of her children had at least some college and several of them were associated with schools, probably due to Lena's commitment to education. She had 20 grandchildren and numerous great-grandchildren when she died at the age of 88. (Courtesy of Linda Morrison.)

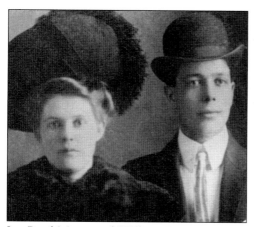

Iva Pearl Meyer and William Dupen married around 1900. William worked in jewelry stores, first in Woodland, then in Oroville, and finally in Sacramento. They moved to Carmichael in the 1930s. William also served as a president of the Carmichael Improvement Club at one time. (Courtesy of Sharon Hencken Cheatham.)

The three children of Iva and William Dupen, from left to right, were Gladys, William, and Lovenia. At the time of their father's death in 1977, the two girls were married and lived on part of the old family holdings while William Jr. lived and worked in Sacramento. (Courtesy of Sharon Hencken Cheatham.)

A much later picture, c. 1947, shows William and Iva Dupen in the beautiful yard of the home they occupied for 30 years. (Courtesy of Sharon Hencken Cheatham.)

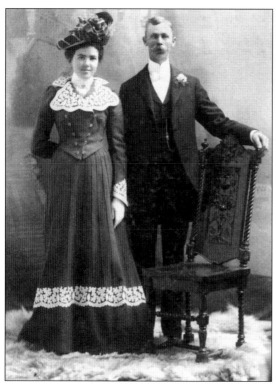

This wedding picture of Katherine and Fred H. Dickson was taken in 1900. The couple moved to Carmichael in 1919 and lived in the same place for 31 years. Fred was a streetcar conductor in Sacramento as well as a carpenter in Carmichael. Katherine was a homemaker who cared for her three children. (Courtesy of Dorothy Dickson St. John.)

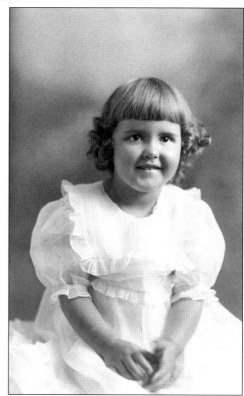

Dorothy Dickson, daughter of Katherine and Fred Dickson, is pictured here around 1924. (Courtesy of Dorothy Dickson St. John.)

Olive Davis, born on September 5, 1888, moved to Carmichael in 1915. She is shown here on the occasion of her 90th birthday in 1978 with four of her five children, including, from left to right, Donald Davis, Laura Davis Martin, Olive, Helen Davis Andersen, and Elbert Davis. Olive and her husband, Stephan, were caretakers of a 20-acre ranch belonging to H.L. Nelson between Landis and Grant Avenues east of California Avenue. Olive once stated, "I consider myself fortunate in having raised my five children in such a fine community." (Courtesy of Carolynn Petersen.)

Four of Olive Davis's seven grandchildren came to the party. Shown, from left to right, are Richard Martin, Carolynn Petersen, Olive, Donna Davis Garner, and ElRoy Davis. Olive was an early example of a Carmichael commuter; she worked in the Weinstock-Lubin store at Twelfth and K Streets in downtown Sacramento for 31 years, retiring in 1958. (Courtesy of Carolynn Petersen.)

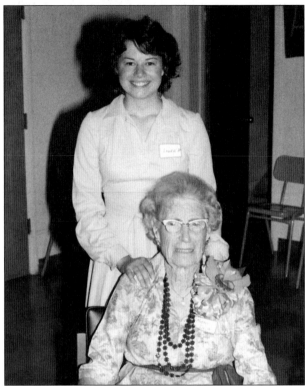

Laura Petersen is one of the great-grandchildren attending the 90th birthday celebration. Olive continued to be an active member of the Carmichael Presbyterian Church, where she had been a member of the church's very first choir in 1925. (Courtesy of Carolyn Petersen.)

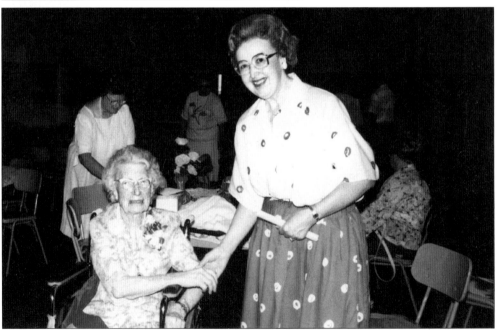

Dorothy Dickson St. John congratulates Olive Davis at her 100th birthday party. Olive passed away on July 8, 1993, less than two months short of her 105th birthday. Jim Cowan said of Olive, "she was an example of the pioneer stock that came and developed Carmichael from its beginning." (Courtesy of Dorothy Dickson St. John.)

Walter H. and Blanche E. Dickson
stand on either side of their children,
Donald and Idell, in front of the
orchard at their farm on Palm Avenue.
In 1922 the Dicksons moved to
Carmichael from Elk Grove where the
Dickson family had homesteaded
in the 1850s. (Courtesy of Idell
Dickson King.)

Idell Dickson graduated from San Juan
High School in June 1938. There was
no high school in Carmichael, so all of
the students had to go to San Juan.
(Courtesy of Idell Dickson King.)

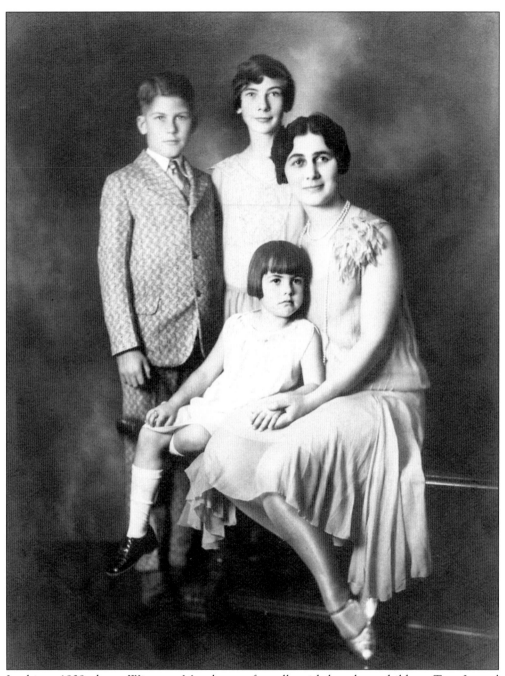

In this c. 1929 photo, Winonne Mapel poses formally with her three children, Tom Jr. and Leila (standing), and Dorothy (seated). All of the children were longtime residents of the area. (Courtesy of Dorothy Mapel Owens.)

In 1926 Thomas G. Mapel brought his family to Carmichael from Sacramento. Tom worked in real estate and later as a developer and also served several terms as a member of the Carmichael Irrigation District Board. He and his wife lived out their lives in Carmichael. (Courtesy of Dorothy Mapel Owens.)

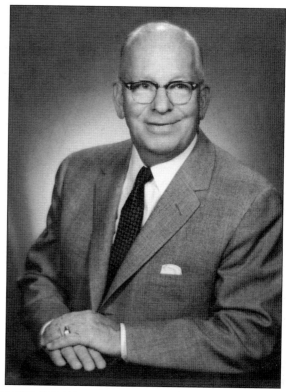

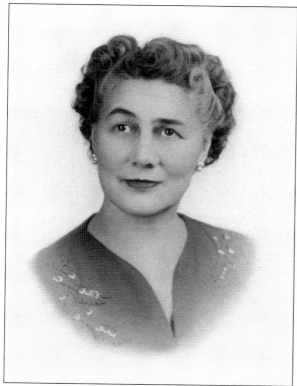

Winonne Mapel actively volunteered her time to schools, church, and community. She was especially involved in the Red Cross and was instrumental in introducing lunch programs in the schools. (Courtesy of Dorothy Mapel Owens.)

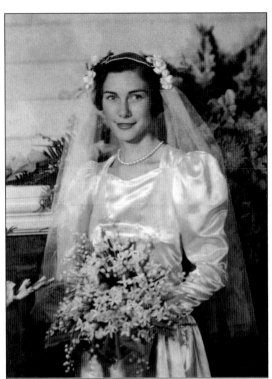

Leila Mapel married James Cowan in 1937 and raised a son and two daughters. (Courtesy of Linda Morrison.)

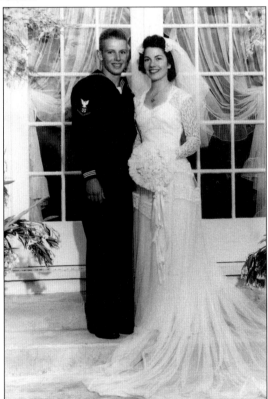

Dorothy Mapel married her high school sweetheart, John "Jack" Owens, on July 8, 1945. He returned to active duty in the Pacific shortly after the wedding but was home by Thanksgiving. (Courtesy of Dorothy Mapel Owens.)

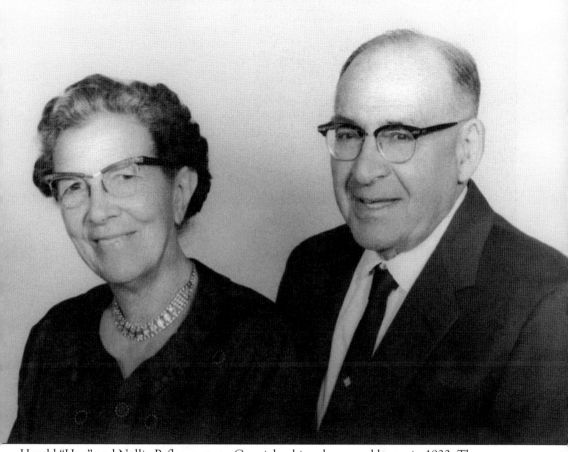

Harold "Hap" and Nellie Pefley came to Carmichael in a horse and buggy in 1922. The grapes they planted still grow on their 10 acres on the south side of Palm Avenue. This picture was taken in 1967 on their 50th wedding anniversary. (Courtesy of Jack Pefley.)

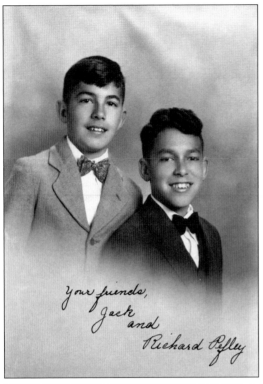

Jack (left) and Richard Pefley, ages eight and ten, were both born in Carmichael. Jack went into the U.S. Navy and retired as a commander. He still lives on part of the original farm and remembers Carmichael as a wonderful place to grow up. Richard became an engineering professor and taught at Santa Clara University. (Courtesy of Dorothy Dickson St. John.)

your friends,
Jack
and
Richard Pefley

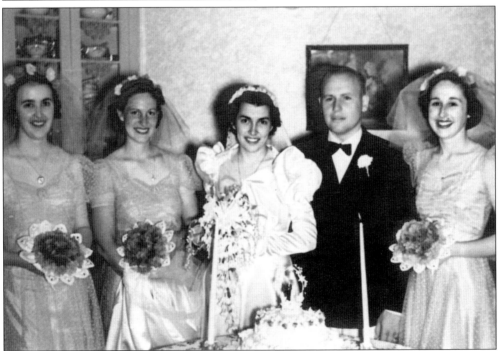

The third Pefley child, Barbara, is shown here at her wedding when she married Myron Sargent on June 15, 1940. Her attendants, from left to right, are Dorothy Dickson, Charlotte Holsinger, and her college roommate, Margaret Peacock. (Courtesy of Dorothy Dickson St. John.)

Frankie Porter, at about the age of 20, is shown here around the time she married William F. Clark in 1899. When the family arrived in Carmichael in 1920, there were five children: Porter, Osborn, Evelyn, Paul, and Justin. They lived for a time on Fair Oaks Boulevard just east of California before moving to their permanent home between Marconi and Kenneth Avenues west of Fair Oaks where they had an orange grove. (Courtesy of A.L. "Red" Hughes.)

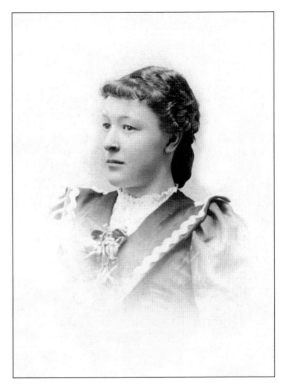

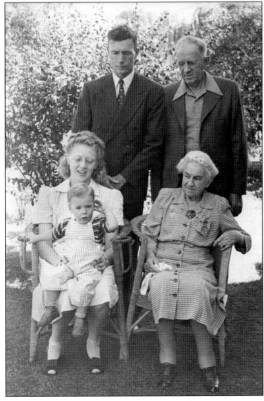

Five generations of the Clark family are pictured in this 1944 photo, including, from left to right, (standing) Porter and his father, Bill; (seated) Porter's wife, Mary Emily (holding Wade), and Mr. Clark's mother. (Courtesy of A.L. "Red" Hughes.)

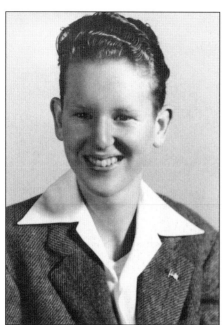

Leroy Hughes, better known as "Red," was a beaming eighth-grade graduate in 1943. Active in music programs throughout his school career, Red went on to become a band instructor at El Camino High School. (Courtesy of A.L. "Red" Hughes.)

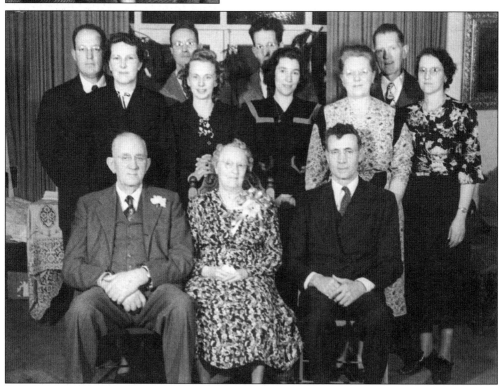

William F. and Frankie P. Clark are seated in the front row for this family portrait, taken February 6, 1949, for their golden wedding anniversary celebration. Seated next to them is their oldest son, Porter. The people standing behind them, from left to right, are Osborn and Charlene Clark, Justin and Dorothy Clark, Paul and Carleen Clark, Bertha Clark, and Glenn and Mary Evelyn Clark Hughes. (Courtesy of A.L. "Red" Hughes.)

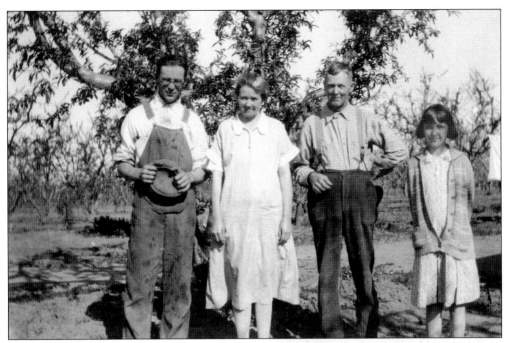

Elmer Dickson (left) is standing next to his parents, Katherine and Fred Dickson, and his sister Dorothy in front of their peach orchard in the spring of 1929. Dorothy remembers working in the orchard and cutting peaches and apricots for drying. (Courtesy of Dorothy Dickson St. John.)

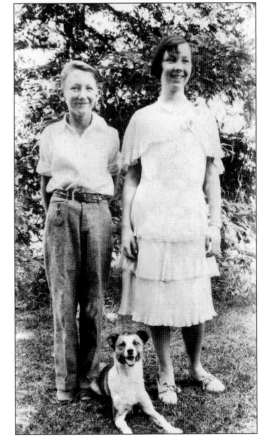

Dick and Lucille Dickson, the children of Wiley and Mabel Dickson, lived and helped out on their parents' turkey ranch. One of their chores was to turn the turkey eggs as they were incubating—30,000 of them! Their farm was on the north side of Winding Way near Dewey Drive. (Courtesy of Betty Gibbons Schei.)

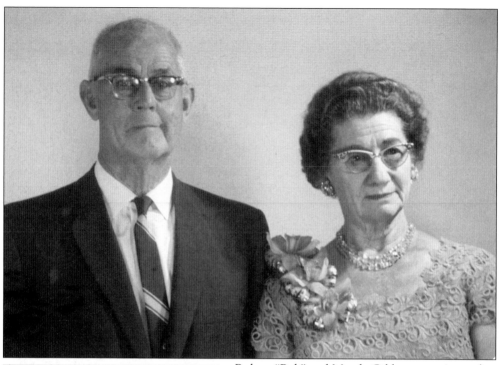

Robert "Bob" and Maude Gibbons are pictured here on their 50th wedding anniversary in the late 1970s. Bob Gibbons was one of Carmichael's successful farmers and dairymen. They raised four daughters on their place on what is now Gibbons Drive. (Courtesy of Roberta Oldham Gibbons.)

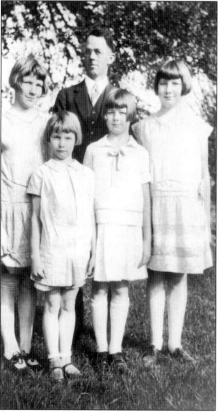

Bob Gibbons is shown in front of an almond tree in the family orchard with his four daughters, c. 1930. The daughters, from left to right, are Laverne, Betty, Elsie, and Roberta. (Courtesy of Betty Gibbons Schei.)

Betty Gibbons, age 16, was a student at San Juan High School. She later married and now lives in Arden Park. (Courtesy of Roberta Gibbons Oldham.)

This is probably the high school graduation picture of Roberta Gibbons. She is a talented artist and still lives in Carmichael. (Courtesy of Linda Morrison.)

Elsie Gibbons, who worked for the state after World War II, is shown here in 1947. She lives near her sister Roberta in Carmichael. (Courtesy of Roberta Gibbons Oldham.)

Evans Clark, shown here as a young man, moved his wife and his oldest two children from San Francisco to Carmichael in 1929. He established a garage on Fair Oaks Boulevard just south of Palm Drive. (Courtesy of Evans "Red" Clark Jr.)

Edna Clark was widowed in 1940 with four children to support. She became the assessor-collector of the Carmichael Irrigation District and served in that position until her retirement in 1966. She always credited Carmichael as a wonderful place to raise children. This photo shows Edna on her 90th birthday. (Courtesy of Evans "Red" Clark Jr.)

Mr. and Mrs. Ingram lived on Palm Drive when this picture was taken in 1927. Mrs. Ingram's first name is believed to have been Effie; Mr. Ingram's first name is lost in time. (Courtesy of Dorothy Dickson St. John.)

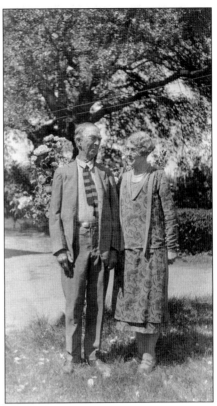

Another neighbor on Palm Drive was Alfred Bennett, who worked on the Deterding ranch. (Courtesy of Dorothy Dickson St. John.)

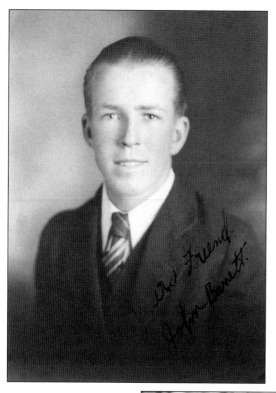

John Barrett Jr. is the son of one of the earliest families in the area. This photo is believed to be his high school graduation portrait. His father, John, and uncle William settled just north of Lincoln Drive, which was the northern boundary of the original Carmichael Colony No. 1, but within present Carmichael. The Barretts arrived in early 1900. Both were farmers and community supporters. Rosalie and John Barrett Sr. farmed 80 acres on the west side of Barrett Road. (Courtesy of Linda Morrison.)

Effie May Cummings, born on May 5, 1900, was an important influence on the education of Carmichael children in the areas of nature and the environment. She married William H. Yeaw (rhymes with saw) in 1933. She had been a teacher before her marriage and resumed that occupation after her three children were born. Her kindergarten classes always had birds, raccoons, or other wildlife living in the classroom. (Courtesy of Effie Yeaw Nature Center.)

Doris Graves married Joe Chez, whom she met while attending Stanford University. Rev. James Comfort Smith officiated at the wedding in the Carmichael Presbyterian Church on February 21, 1953. Doris is now a dedicated genealogist, and Joe entertains children in the hospital with his magic show. (Courtesy of Doris Graves Chez.)

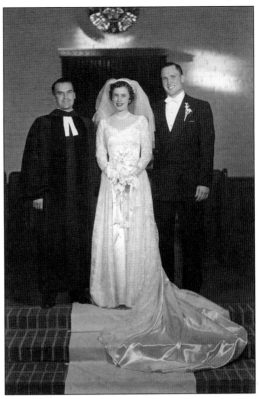

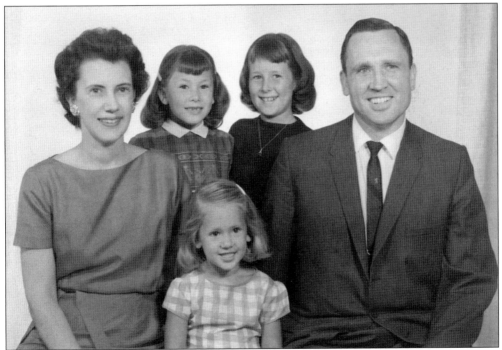

Doris and Joe Chez flank their three children, Leslie and Karen (standing) and Alison (seated in front), in this 1963 photograph. (Courtesy of Doris Graves Chez.)

Dorothy Dickson married Roy St. John on June 18, 1950. His best man was his brother Don and the maid of honor was Barbara Pefley. (Courtesy of Dorothy Dickson St. John.)

This Christmas portrait of Lawrence and Laura May McGuirk and their two teenaged daughters, Virginia and Irene, was taken in 1948. (Courtesy of Irene McGuirk Hannum.)

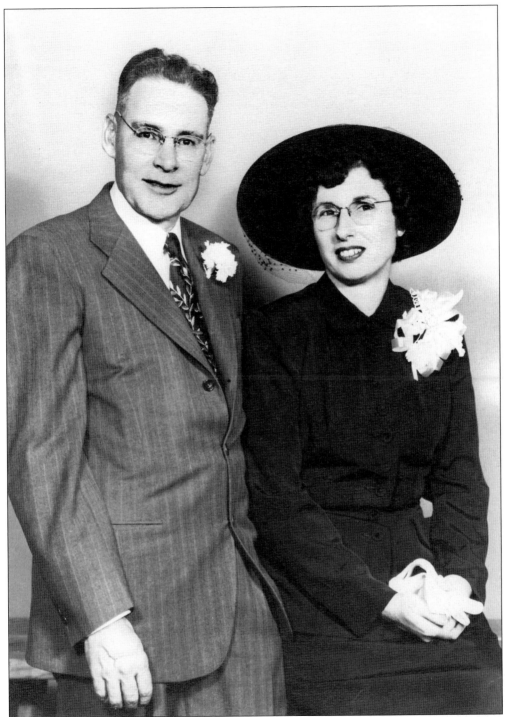

Carl and Florence Davis Anderson were married on October 7, 1950. Florence is the daughter of the pioneer Davis family. Carl worked as a tax collector for the federal government but was perhaps better known as a leader of stargazers, serving as president of the Sacramento Valley Astronomical Society. (Courtesy of Dorothy Dickson St. John.)

Carl and Lovena Dupin Hencken celebrated their 50th wedding anniversary in 1979. Carl built the family home near Lovena's parents and that was where they raised their three children. (Courtesy of Sharon Hencken Cheatham.)

Pictured here are the three Hencken children and their spouses: Carl Jr. (known as Jerry) and Betty (in front), Frances and Bob (on the left), and Larry and Sharon Cheatham (on the right). (Courtesy of Sharon Hencken Cheatham.)

Two
CARMICHAEL AT WORK

Carmichael was founded on the assumption that the land would prove fertile enough that farmers could be self-sufficient on 10 acres of land. That proved not to be so. One of the first difficulties farmers encountered was hard pan, a thick layer of solidified clay so tough that it took dynamite to blast a hole in it. This layer lurked 6 to 20 inches below the surface, too close to permit young trees enough space for good root growth. The next problem was the disastrous decline of agricultural prices after World War I, a bad situation that only worsened with the Great Depression. Still, the town held on.

One way to make a living was to diversify. Farmers added wheat, almonds, chickens, and turkeys to their farms. Dairymen raised and milked cows. Cows and horses needed to be fed, so some farmers planted hay.

As cars began to appear, so did service stations. Grocery stores meant no more long trips to Sacramento for goods. Schools needed teachers, churches needed preachers, and new houses needed carpenters, brick layers, and plumbers. By 1918 H Street was paved, making it possible for workers to commute from Carmichael into Sacramento, a practice that has continued (and grown) to the present day.

Whatever it took, Carmichael residents found a way to make a living and to maintain the community they built.

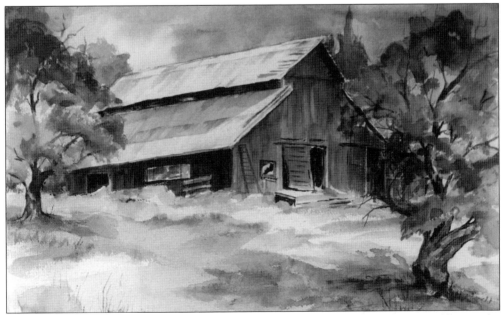

This is the Deterding barn as painted by local Carmichael artist Roberta Gibbons Oldham. The barn served as a landmark for many years, especially to fliers stationed at Mather Field between the World Wars who used the barn to plot their course back to the base. (Courtesy of Roberta Gibbons Oldham.)

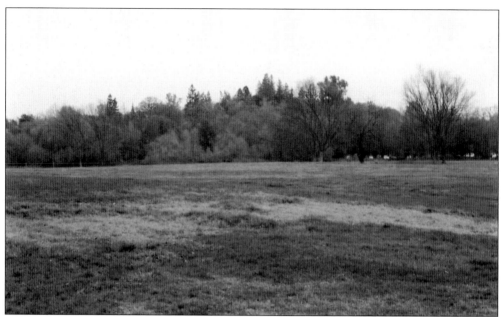

This photo shows a portion of Ancil Hoffman Park, which is part of the 425 acres once owned by the Deterding family. Because Charles Deterding planted a lot of alfalfa, it was known as San Juan Meadows. Orchards of pears, peaches, and prunes were also cultivated here. (Courtesy of Kay Muther.)

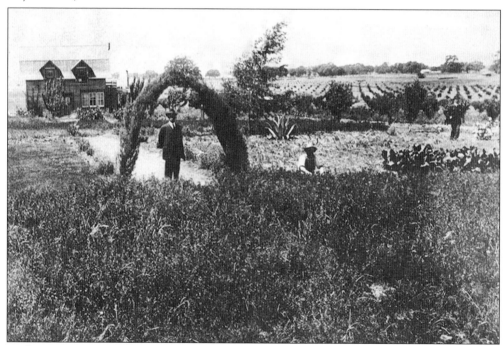

Fred E. Graves stands in front of the house on his 100 acres, which ran from Garfield to Fair Oaks on the north side of Garfield Avenue. His new orchard can be seen on the right side of the picture. Unfortunately, Graves died in a blasting accident in 1916, and his land was divided among family members. (Courtesy of Doris Graves Chez.)

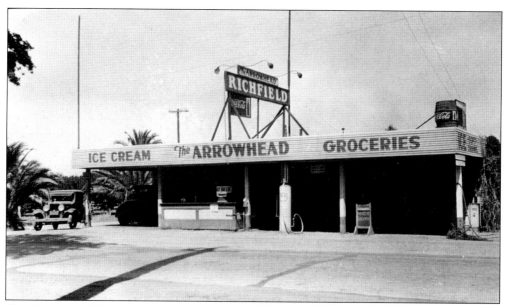

The Arrowhead Store was converted from an old fruit packing house by owners Gilmore and Elizabeth Davis in 1920. Located at the corner of Palm and Fair Oaks, it served as a grocery store, meat market, and soda fountain until the Davis family sold out in 1929. The new owner moved the Arrowhead across the street and expanded it. (Courtesy of Dorothy Dickson St. John.)

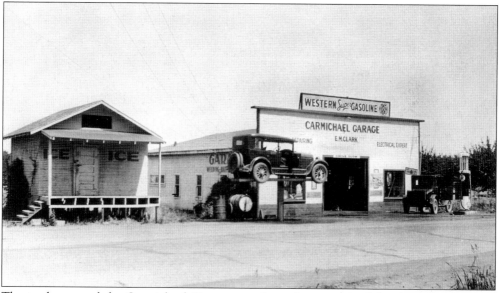

The ice house and the Carmichael Garage were located just south of the Arrowhead on Fair Oaks Boulevard. This picture was taken in 1932 after the buildings had been there for several years. Evans Clark bought the garage in 1929, and his son "Red" Clark said it had the first lift for car repairs in town. The lift didn't work very well and had to be propped up with two-by-fours to keep cars from sliding down as they were being worked on. (Courtesy of Dorothy Dickson St. John.)

A wagon load of watermelon had been taken to Sacramento for sale, but most of it ended up returning to the Graves farm. "Whatever will we do with all this watermelon?" Clara Graves was asked. "Why, we eat it!" she replied. This picture shows them doing just that. (Courtesy of Doris Graves Chez.)

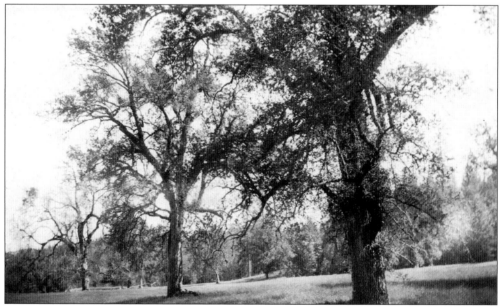

This photo shows the oak-studded pasture where Robert "Bob" Gibbons ran 100 head of dairy cattle. Bob and Elsie Gibbons had 40 acres between Walnut Avenue and Garfield just south of Winding Way. In addition to the dairy, the farm had crops of almonds and prunes. (Courtesy of Betty Gibbons Schei.)

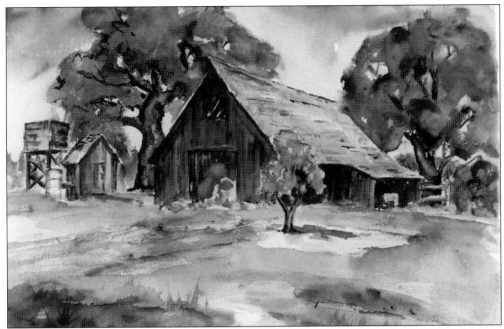

This is the barn on the Gibbons farm as remembered and painted by Roberta Gibbons Oldham. The pump house is the small building to the left of the barn. (Courtesy of Roberta Gibbons Oldham.)

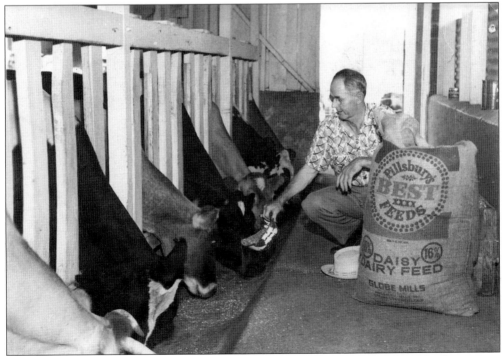

Bob Gibbons is shown here feeding his cattle. Many Carmichael residents have fond memories of the Gibbons Dairy because it was available for school tours on a regular basis. It was one of the early dairies to have a drive-in service. (Courtesy of Roberta Gibbons Oldham.)

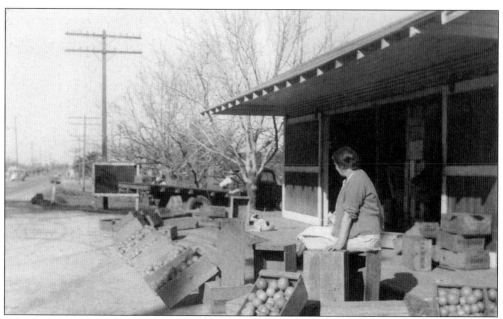

Blanche Dickson is shown here taking care of the family fruit stand on Fair Oaks Boulevard near Marconi Avenue. Several Carmichael farmers offered fresh fruits and vegetables at similar roadside stands. (Courtesy of Idell Dickson King.)

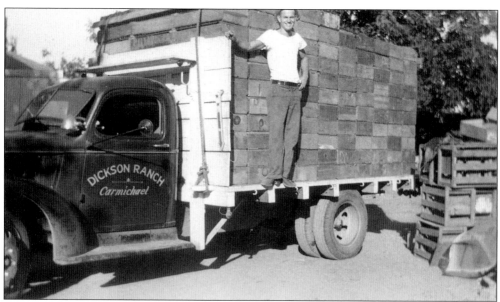

Donald W. Dickson has a load of fruit ready for the market. The Dicksons raised peaches, apricots, plums, and oranges on about 19 acres. (Courtesy of Idell Dickson King.)

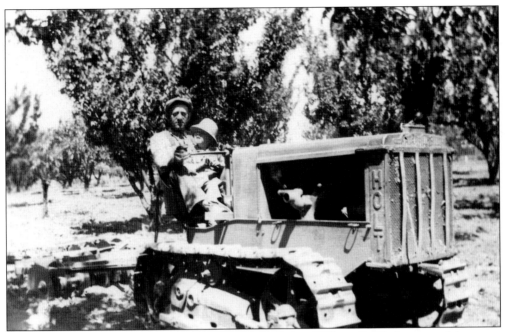

A.L. "Red" Hughes is shown here helping his grandfather William F. Clark operate his tractor c. 1933. Mr. Clark had an orange grove on the west side of Fair Oaks Boulevard between Marconi and Kenneth Avenues. (Courtesy of A.L. "Red" Hughes.)

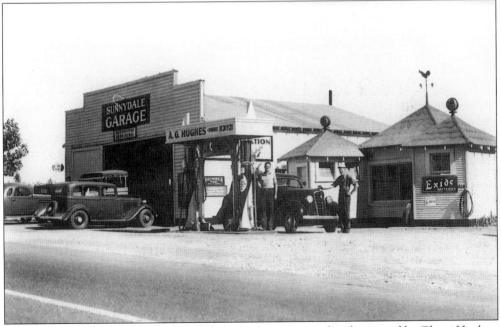

Beginning in the late 1920s, the Sunnydale Garage was owned and operated by Glenn Hughes, shown here on the right, with the help of his brother-in-law Justin Clark. Located just east of California Avenue on Fair Oaks Boulevard, the garage did auto repairs and sold regular and ethyl gasoline. Glenn Hughes let his son "Red" pump gas and wash windshields when he was a seventh-grader at nearby Carmichael School. (Courtesy of A.L. "Red" Hughes.)

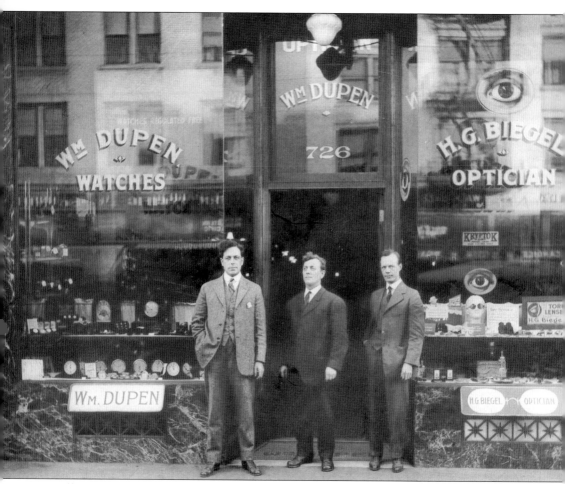

William Dupen (left) was one of the earliest commuters from Carmichael to Sacramento, where he had a jewelry business. When the store failed during the Depression, Dupen repaired and restored rare old clocks and watches. Both his father and his grandfather before him had been watchmakers. (Courtesy of Sharon Hencken Cheatham.)

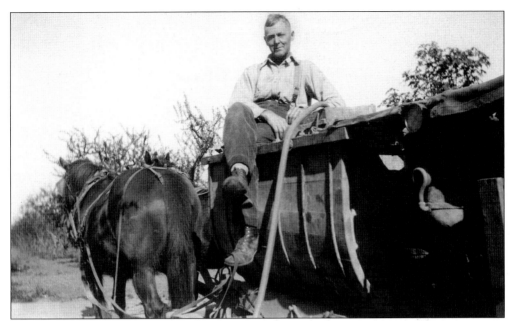

Fred Dickson rides the spray wagon on his 10-acre farm in 1929. The peaches were sprayed for pests and to prevent peach leaf curl. (Courtesy of Dorothy Dickson St. John.)

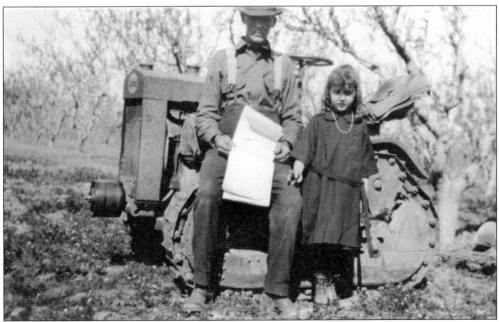

The Dickson orchard can be seen in the background while Fred and daughter Dorothy check out the tractor. (Courtesy of Dorothy Dickson St. John.)

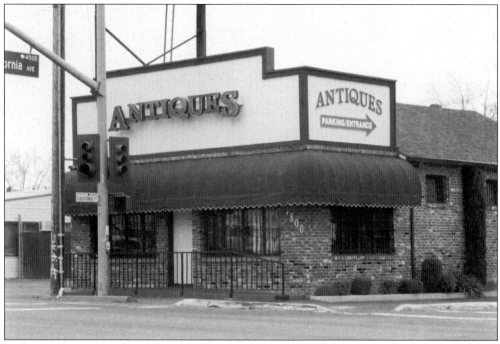

This antique store was previously occupied by the Red and White Grocery. Located at the corner of California Avenue and Fair Oaks Boulevard, the grocery operated for about 40 years. (Courtesy of Kay Muther.)

Library services in Carmichael began *c*. 1923 in the home of Sara Lott, who kept about 100 books to lend to readers. In 1941 a small library was built on the south side of Marconi with Emma Cole as librarian, a position she held until 1957. About that time, the present library on the north side of Marconi, pictured above, was occupied. (Courtesy of Kay Muther.)

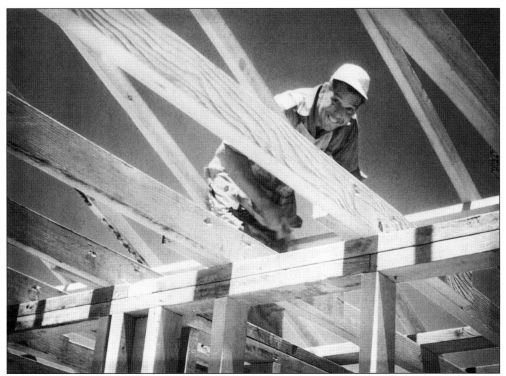

Carl Hencken was a popular builder and carpenter from the time he moved to Carmichael in 1936. Here he is shown framing a house in 1945. (Courtesy of Sharon Hencken Cheatham.)

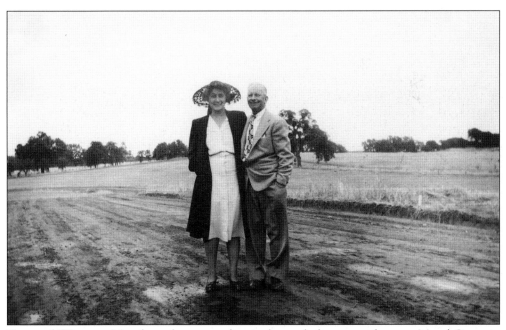

Tom and Winonne Mapel are shown standing in front of what was to become Mapel Grove in 1946. Tom Mapel had been in real estate for years before he began this 100-acre development east of Barrett Road and south of Winding Way. (Courtesy of Dorothy Mapel Owens.)

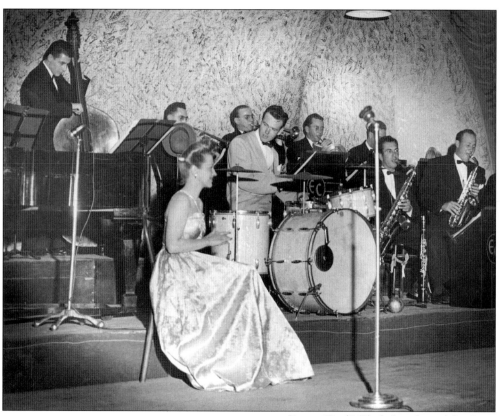

Evans "Red" Clark (on drums) leads his band as they play for the Carmichael Fireman's Ball in 1951. The lovely singer is his wife, Doris. The Fireman's Ball was the big social event of the year. (Courtesy of Evans "Red" Clark.)

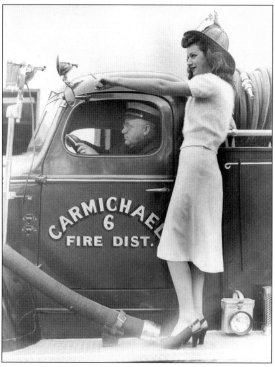

Speaking of firemen, Dan Donovan, the volunteer chief of the fire department from 1927 to 1965, is shown here driving a fire truck. The unidentified young woman on the running board is telling him where to go! (Courtesy of Carmichael Chamber of Commerce.)

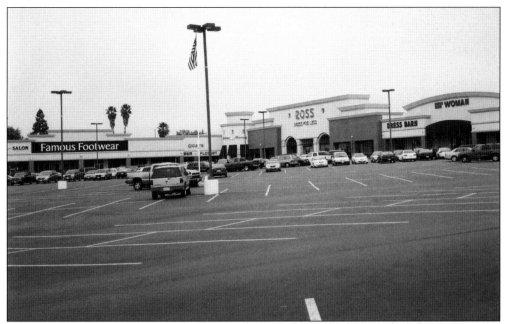

The Crestview Center was the first major shopping center in Carmichael, built in 1963 by Dick Holesapple at the corner of Manzanita Avenue and Winding Way. This contemporary photo shows the center as it is today after numerous changes over the years. (Courtesy of Kay Muther.)

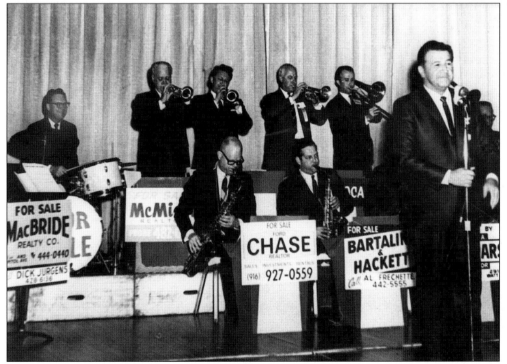

A real estate board luncheon was entertained by a pick-up band, directed by Dick Jurgens, in 1966. All members of the band are either real estate agents or men in real estate finance, including Evans "Red" Clark on drums. (Courtesy of Evans "Red" Clark.)

Early mail was delivered in Carmichael out of the Fair Oaks post office by Bob Massey. An earlier post office on Palm Avenue was replaced by this larger new facility on Fair Oaks Boulevard. (Courtesy of Kay Muther.)

The Carmichael Fire District was formally organized in 1942, and a fire station was built at Donovan's Corners, Garfield at Fair Oaks. The second station was built on Fair Oaks west of California. Neither of those stations is still standing, but Fire Station No. 3, built in 1957 at the corner of Dewey Drive and Winding Way, is still in operation. (Courtesy of Kay Muther.)

Three

HOMES

Carmichael has always been a place for families and their homes. Adobe houses, log cabins, or frame houses, they all were homes.

Except for the Deterdings, whose ranch was next to the American River, the first homes were built along Fair Oaks Boulevard, to the east on Palm Drive and California Avenue, and to the west along Marconi Avenue and El Camino. Fair Oaks Boulevard, which was called H Street for years, was the only paved road in the 1920s. It was a narrow, two-lane road all the way to Sacramento.

Both of the Carmichael colonies offered 10-acre lots, but some families bought more than one parcel. Many of the early homes were built by their owners, either alone or in concert with friends, neighbors, or other family members. By the mid-1920s, about 300 families were living in Carmichael. Some of the original homes are still standing.

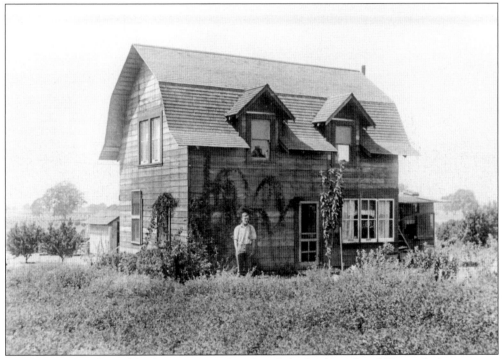

The home of Fred E. and Clara M. Graves at Fair Oaks Boulevard and Kenneth Avenue was completed in 1914. Their son Bayard is shown here standing in front of the building, which was intended to be the barn but was used as a home. Bayard bought the surrounding 10 acres and lived there until 1951. (Courtesy of Doris Graves Chez.)

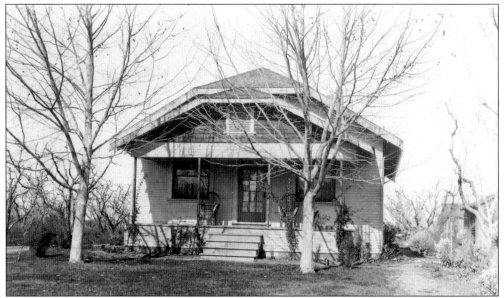

The home of Fred H. and Katherine Dickson on Palm Drive was built in 1919. The family lived in a small "shanty," according to their daughter Dorothy, while Fred, a carpenter, constructed this home himself. (Courtesy of Dorothy Dickson St. John.)

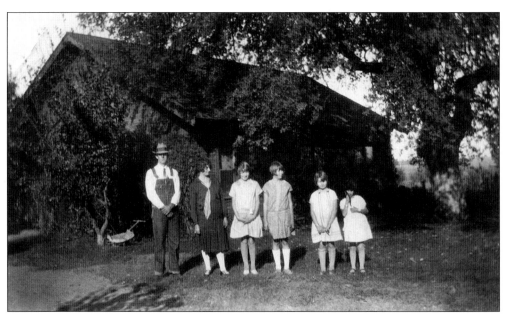

Laverne, Roberta, Elsie, and Betty Gibbons stand in front of their home with their parents, Robert L. "Bob" and Maude Gibbons. The ranch house was built in 1921 and this picture was taken in 1928. (Courtesy of Betty Gibbons Schei.)

Blanche Dickson, shown here on the right, is standing in front of her home on Palm Drive with an unnamed friend. Blanche and Walter Dickson and their daughter Idell moved to this home from Elk Grove in 1922. Their son Donald was born in this house, and at least part of the family lived here until 1980. (Courtesy of Idell Dickson King.)

Harold and Nellie Pefley moved into this home in 1926. Many of the grapevines that were planted then are still living. Their son Jack lives next door to this home and his son and family occupy the old homestead. Jack reports that the little sidewalk in front of the house was the only one in the neighborhood, and children came from blocks around to roller skate on it. (Courtesy of Kay Muther.)

Leila and Tom Mapel Jr. are standing next to the 1940 home of their parents, Thomas G. and Winnone Mapel. The house was located on Fair Oaks Boulevard near California Avenue. (Courtesy of Linda Morrison.)

Gilmore and Elizabeth Davis owned this home, which was built in 1929 on Palm Drive near Fair Oaks Boulevard. There were originally two homes at this site, according to their son Bob Davis, plus 80 acres mostly in peaches and apricots. (Courtesy of Bob Davis.)

The home of Bayard and Elsie Graves on Kenneth Avenue has a beautifully detailed playhouse at the right. Doris Jane Graves is in her wagon in front of the home in 1931. (Courtesy of Doris Graves Chez.)

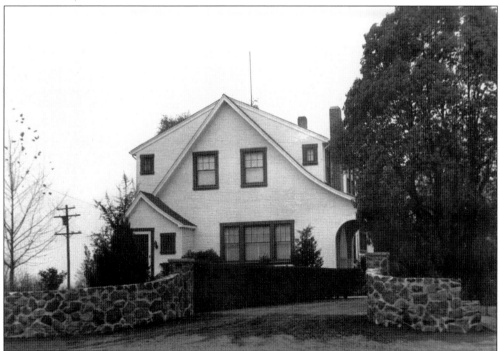

William and Iva Dupen lived in this stately home on Marconi Avenue from 1937 until William's death in 1967. The house was built on 10 acres Dupen purchased in the original Carmichael Colony and had been planted in fruit and olives before it was subdivided. (Courtesy of Sharon Hencken Cheatham.)

The home of Lawrence and Laura May McGuirk at 2721 California Avenue was surrounded by orange trees when they moved there in January 1939. McGuirk worked at the McClellan Air Base rather than depending on the orchard for a living. (Courtesy of Irene McGuirk Hannum.)

James and Leila Mapel Cowan moved to this home on Marconi Avenue in 1939. Leila lived here until 1980, according to her daughter Linda Morrison. (Courtesy of Linda Morrison.)

This 1940 picture of the home of Bob and Maude Gibbons shows the dormer addition as well as an abandoned lawn mower in the front. (Courtesy of Betty Gibbons Schei.)

Effie and Bill Yeaw lived in a former chicken house on their five-acre farm until this comfortable home was built at the corner of Palm Drive and Panama Avenue in 1941. They raised three children, Galen, Ellen, and Edward, here. (Courtesy of Kay Muther.)

Carl and Lovena Hencken moved to Carmichael and lived next door to Lovena's parents, the Dupens. Hencken, a builder, constructed this home at 2940 Garfield, which the family occupied in 1943. (Courtesy of Sharon Hencken Cheatham.)

This was the first home in Mapel Grove, completed in 1946. It belonged to Tom Mapel and his wife, Winonne, developers of that 100-acre subdivision. (Courtesy of Dorothy Mapel Owens.)

Four

CHURCH LIFE

When the Carmichael colonies were settled, the nearest churches were in Fair Oaks, more than five miles away over primitive roads. In 1918 three mothers met and decided it was time to provide Sunday school for their children. Soon, eight Cowan children, four Ellithorpes, and Clarence Champlin were meeting in the Carmichael School with volunteer teachers. Every week Marie Shumate would drive her horse-drawn wagon to pick up the children and deliver them to Sunday school. Before long, others joined them and 50 to 75 attended regularly.

In 1923 church services for adults were held after Sunday school with Rev. J.W. Babcock, a retired Methodist minister, officiating. The congregation formally organized as the Carmichael Community Church with several Christian denominations represented, including Presbyterians, Methodists, Baptists, Congregationalists, Disciples of Christ, and Unitarians. In 1925 the church voted to affiliate with the Presbyterian Church. The Reverend Samuel J. Holsinger was hired to conduct services every Sunday and to spend two half-days in the parish, all for the sum of $10 per week.

The church continued to meet in the Carmichael School until 1927 when H.A. Hobbs donated land on Marconi Avenue for a church. Church members donated both cash and hard labor and the Ladies' Circle held numerous dinners and bazaars to add to the coffers. Slowly the church grew. A church in Elk Grove donated a bell with a lovely tone to peal out a call to worship. The church was dedicated on October 23, 1927.

Over the years more and more churches were built in Carmichael. Wherever the congregations gathered, the need for churches would not be denied. Today, you need drive only a few blocks to find the nearest church.

The first church in Carmichael was the Carmichael Community Church, built in 1927. The Old Sanctuary is shown here with the Stoner Lodge, which was named for Mrs. Stanley Stoner and was used primarily for Boy Scout meetings. (Courtesy of Carmichael Presbyterian Church.)

67

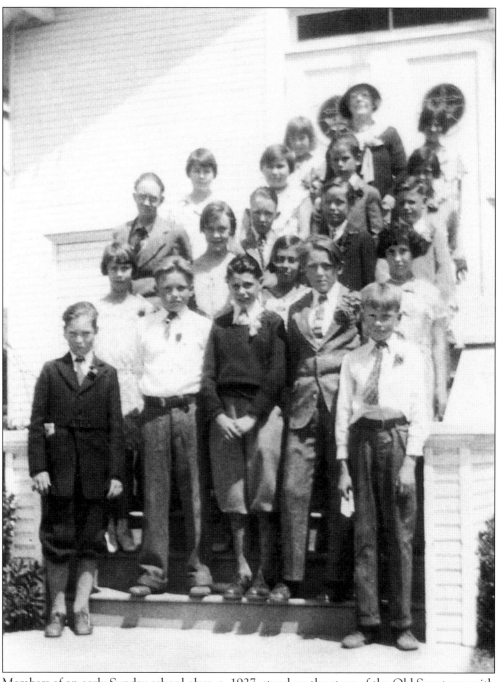

Members of an early Sunday school class, c. 1927, stand on the steps of the Old Sanctuary with their teacher, Effie Yeaw, on the top step. (Courtesy of Carmichael Presbyterian Church.)

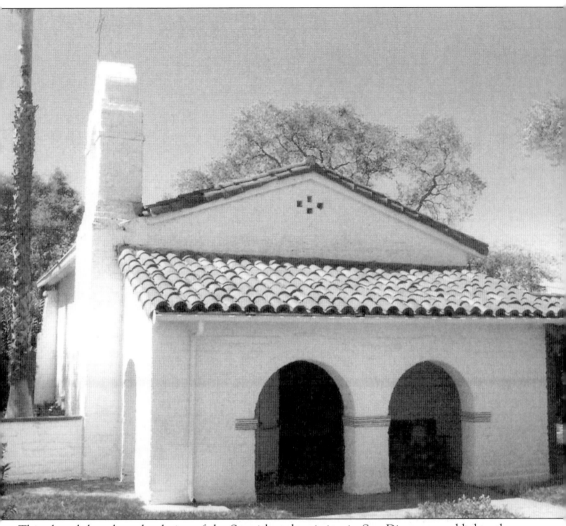

This chapel, based on the design of the Spanish-style mission in San Diego, was added to the campus of the Carmichael Community Church in 1946. High school youth made about 3,000 of the adobe bricks on site; others were excess postwar material from McClellan Air Force Base, which were made available to the church for the cost of hauling them away. (Courtesy of Carmichael Presbyterian Church.)

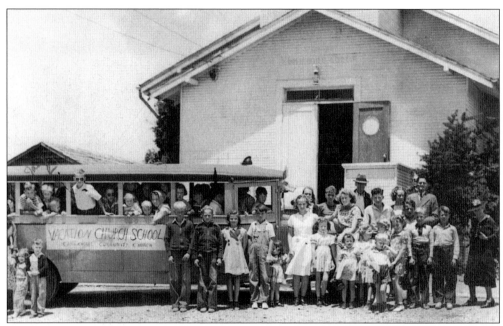

Children attending the Vacation Church School at Carmichael Community Church were picked up and delivered by bus. The exact date of this picture is unknown, but it is probably in the early 1940s since the Old Sanctuary is still in use. (Courtesy of Joe Duarte.)

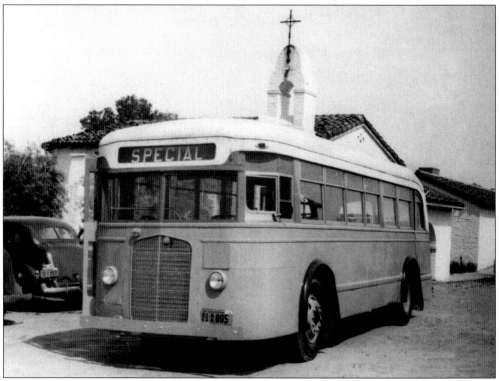

In 1948 the church bus, nicknamed "Ermintrude," first appeared and was beloved by generations of Sunday school children. (Courtesy of Carmichael Presbyterian Church.)

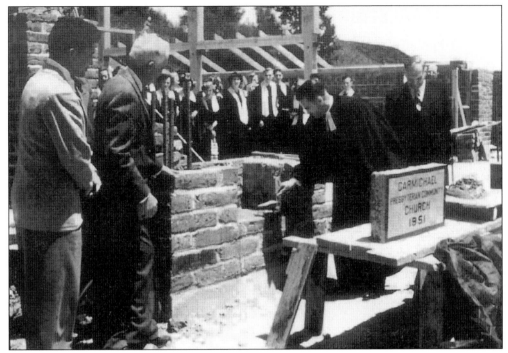

An historic adobe brick from the San Juan Bautista Mission, created by Native Americans in 1795, is laid into the West Chapel wall. The brick symbolizes the continuation of Christianity from its early beginnings to the present day and also signals completion of the west wing of the planned church campus. (Courtesy of Jimmi Mishler.)

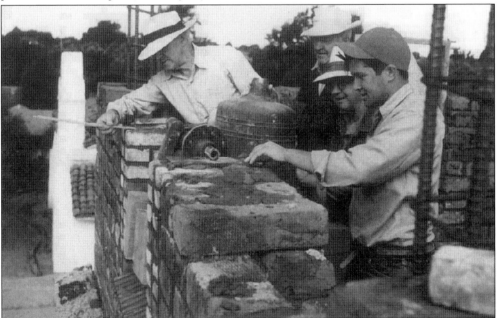

The bell tower for the new sanctuary was nearly complete in this 1951 photo. Now renamed Carmichael Presbyterian Church, the sanctuary took three years to raise the money for the building project. (Courtesy of Jimmi Mishler.)

The new sanctuary was dedicated on December 9, 1951. Members of the congregation participated in the construction of the building at a very reasonable cost. (Courtesy of Carmichael Presbyterian Church.)

This photo from 1977 shows, from left to right, Grace Dickson, Glenn Hughes, Elsie Cosans, Olive Davis, and Maud Gibbons gathered around the sundial built by James Dickson that stands in the church courtyard. These five were active members of the church prior to 1930. (Courtesy of Carmichael Presbyterian Church.)

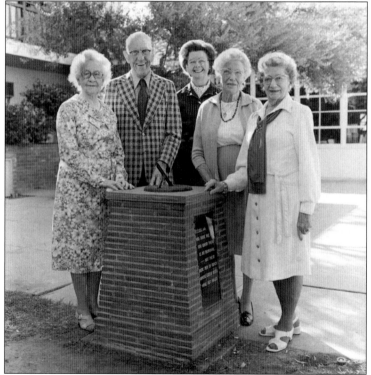

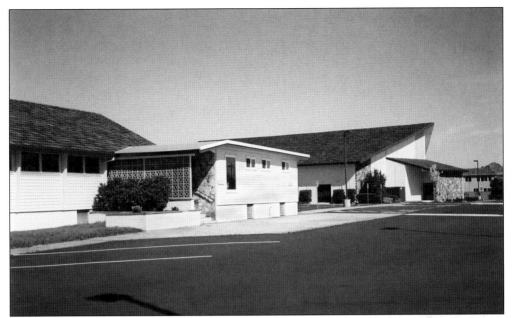

The Carmichael Bible Church, 7100 Fair Oaks Boulevard, was originally the Wayside Chapel, a splinter group that broke off from the Carmichael Presbyterian Church in late 1929. Rev. Samuel Holsinger led members of the congregation desiring a more fundamental approach to Christianity and set up a new church, first meeting in a tent or private homes until an old school building was moved to this spot in September 1930. (Courtesy of Kay Muther.)

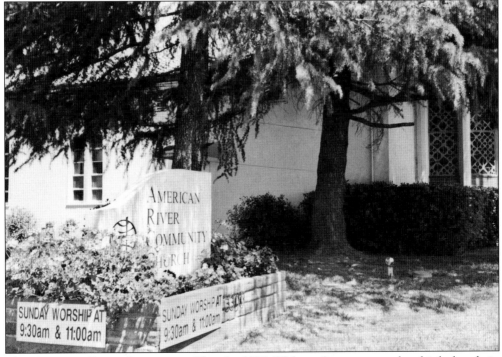

The American River Community Church, 3300 Walnut Avenue, was the third church in Carmichael, built in 1945. (Courtesy of Kay Muther.)

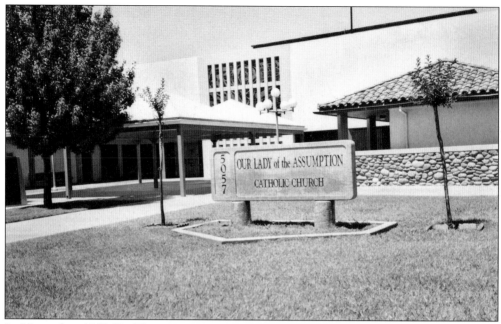

In November 1950 Fr. Thomas Bannon was appointed to serve the Carmichael Catholic community. During the construction of a new church, mass was celebrated in the Rainbow Theater at Fair Oaks Boulevard and Manzanita Avenue. Mothers were heard to say that their children were unsure whether they were going to see Father Bannon or Donald Duck at the theater. Dedication ceremonies for the Our Lady of Assumption Church were held on September 28, 1952. (Courtesy of Kay Muther.)

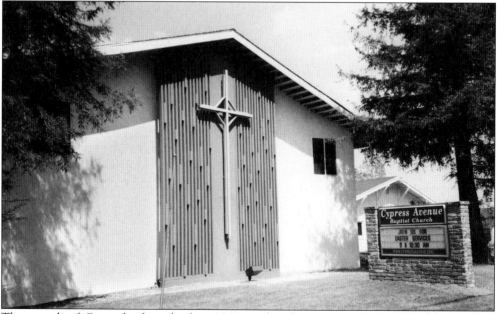

The growth of Carmichael in the late 1940s and early 1950s necessitated building several new churches. Cypress Avenue Baptist Church was completed around 1950. (Courtesy of Kay Muther.)

Construction of Gethsemane Lutheran Church was begun at the corner of Arden Way and Mission Avenue in September 1955. The first worship service was conducted one year later. (Courtesy of Kay Muther.)

The congregation that became St. Michael's Episcopal Church had been meeting as a parochial mission since 1955. The building was completed at 2140 Mission Avenue in 1959. (Courtesy of Kay Muther.)

St. John's Catholic Church at Locust and Hackberry was completed in November 1960. (Courtesy of Kay Muther.)

Christ Community Church began life as the Winding Way Community Church in 1961 and services were conducted in a roller skating rink. The first sanctuary was located on Winding Way near Jan Drive, but explosive growth required construction of a new, much larger facility, which was occupied in 1982. The present church, shown above, is located on Manzanita Avenue near Madison. (Courtesy of Kay Muther.)

The congregation of St. George's Episcopal Church met in private homes for over two years until this facility was built on Winding Way near Hackberry. It was occupied on May 1, 1966. (Courtesy of Kay Muther.)

The Carmichael Baptist Church at 3210 California Avenue was organized in December 1968 and moved into this building in 1970. (Courtesy of Kay Muther.)

Mormons have been present in the region since the days of the gold rush, but this Church of Jesus Christ of Latter Day Saints was built at the corner of Locust and Garfield well over 100 years later. (Courtesy of Kay Muther.)

Five

SCHOOLS

The closest school for early Carmichael Colony children was a one-room building on Winding Way near Dewey Drive, which was used from 1880 to 1917. San Juan Elementary School, just above the northern boundary of the colony, served 15–20 students.

As the population of Carmichael Colony grew, parents were determined to have a school built closer to home. Some of the mothers traveled around the district by horse-drawn buggies to garner support for the new school. Daniel Carmichael agreed to donate 10 acres to the project as long as the new school was named after him.

Members of the Parent Teacher Association donated services and labor to help build the two-room school on the corner of California and Sutter Avenues, which opened in 1917. Two more rooms were added in 1920. This was the only elementary school in Carmichael until the 1950s.

From modest beginnings, the Carmichael school system has grown to include 12 elementary schools and 3 middle schools. Although technically there is no high school in Carmichael, Del Campo High School is surrounded on three sides by Carmichael land and is considered the local high school. The San Juan School District, of which Carmichael is a part, has a reputation for providing excellent educational services to its students.

Carmichael School started as a two-room building in 1917. As the only elementary school in Carmichael until the 1950s, it served several generations of early settlers. It is still in use today with an enrollment of 564 students. (Courtesy of Carmichael Presbyterian Church.)

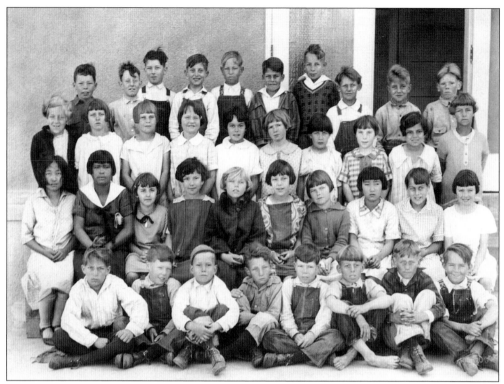

Fifth-graders at Carmichael School in 1929 were allowed to wear bib overalls and come to school in bare feet! (Courtesy of Dorothy Dickson St. John.)

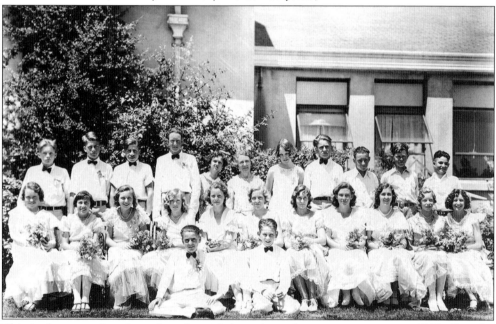

This is the same class dressed up for eighth-grade graduation ceremonies in 1932. Dorothy Dickson, who provided this picture, is third from the left in the middle row. The teacher, in the center of the back row, is Mrs. Frances H. Millsap. (Courtesy of Dorothy Dickson St. John.)

Carmichael School teacher Mrs. Mildred Spurlock is pictured here in 1931. She taught music and seventh grade. (Courtesy of Dorothy Dickson St. John.)

Mrs. Bertha M. Mansfield taught fourth and fifth grades in 1932 as well as English and art to eighth-graders. How did she manage such a load? (Courtesy of Dorothy Dickson St. John.)

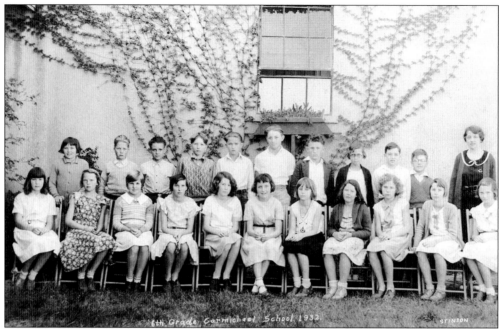

Mrs. Mildred Spurlock (far right, back row) is shown here with her sixth-grade class in 1932. Idell Dickson, who provided this picture, is second from the left in the front row. (Courtesy of Idell Dickson King.)

In 1928, local schoolgirls (from left to right in both photos) Leah Mettier, Barbara Pefly, and Dorothy Dickson were photographed before and after school. (Courtesy of Dorothy Dickson St. John.)

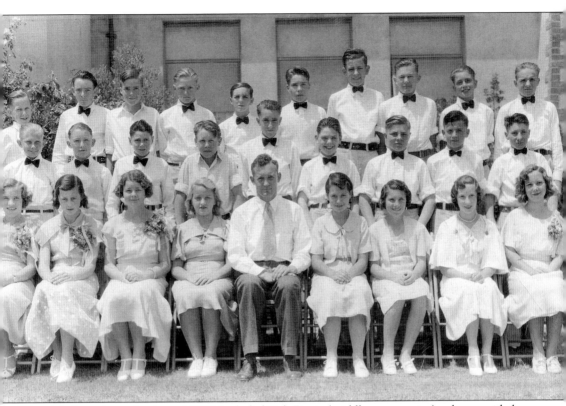

The eighth-grade graduation of 1933 included Bob Davis (middle row, center), who provided this picture. The teacher (front row, center) is Raymond E. Denlay. (Courtesy of Bob Davis.)

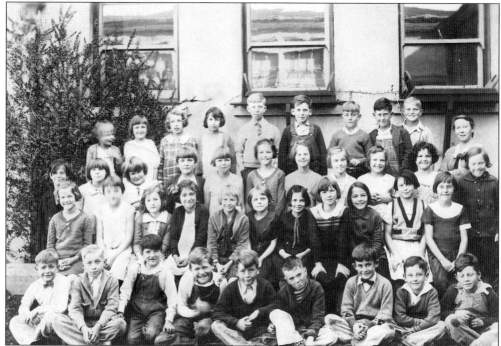

In 1933 Miss Gladys McKeown, far right in the last row, taught a combined second- and third-grade class. (Courtesy of Dorothy Mapel Owens.)

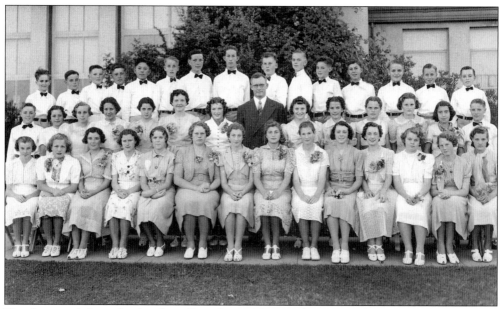

This large eighth-grade class has 42 students. The gentleman standing in the center of the middle row is both the eighth-grade teacher and the principal, Ray Denlay. (Courtesy of Dorothy Mapel Owens.)

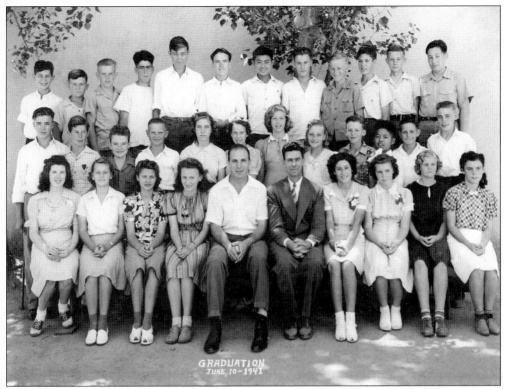

The last of the eighth-grade classes to graduate before World War II was taught by Nicholas Barbieri, shown here in the white shirt in the front row. Seated next to him in this June 1941 photo is Laurel C. Ruff, principal of Carmichael School. (Courtesy of Lowell Stilson.)

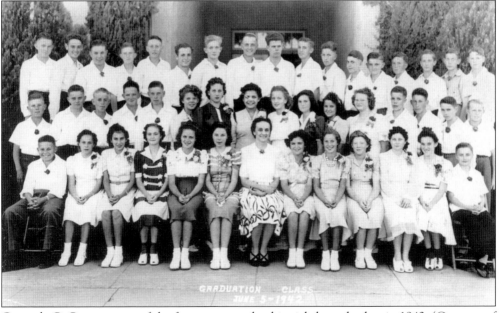

Gertrude C. Coats, center of the front row, taught this eighth-grade class in 1942. (Courtesy of Joe Duarte.)

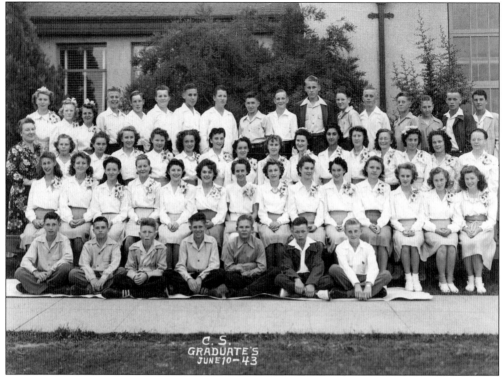

A.L. "Red" Hughes, third from the left in the front row, says this eighth-grade graduation picture is missing the valedictorian, who was sent to a Japanese-American internment camp in the spring of 1943. Their teacher, James Stivers, was drafted, so Marian B. Miller took over the class after the Christmas break. (Courtesy of A.L. "Red" Hughes.)

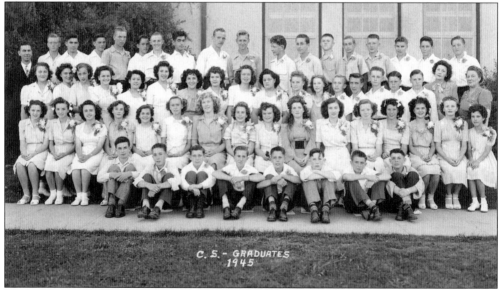

This is a picture of the two eighth-grade classes that graduated in 1945. The two teachers at the right end of the third row are Leah Hinshaw and Eleanor Harshner. Principal Ruff also appears in this photo at the far left. (Courtesy of Irene McGuirk Hannum.)

Students could buy hot lunches at school as shown in this 1948 picture. This cafeteria is in the basement of the school. (Courtesy of Irene McGuirk Hannum.)

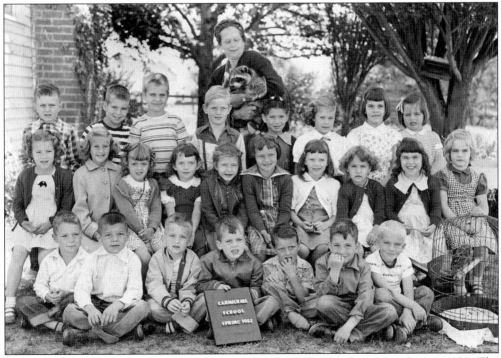

Effie Yeaw, a well-known naturalist, is shown here with her kindergarten class in 1953. The raccoon and bird in the cage are members of the class. (Courtesy of Twila de Vriend.)

By 1957, eighth-grade graduations had become big business at Carmichael Elementary School. Population pressures on the school necessitated the construction of separate middle schools

Starr King in 1956 and John Barrett in 1957. (Courtesy of Sharon Hencken Cheatham.)

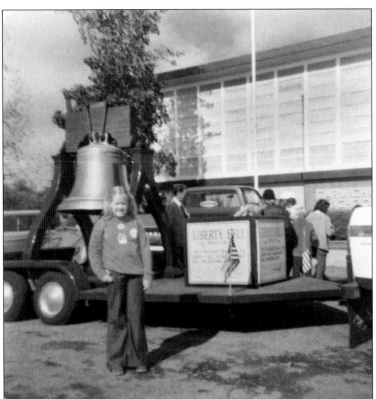

The Liberty Bell visited Carmichael Elementary School during a national tour and is shown here with Claudia Howard. (Courtesy of Claudia Howard.)

Mission Avenue Elementary School, constructed in 1953, recently celebrated its 50th anniversary. The school consisted of eight classrooms. This photo was taken in January 1956. (Courtesy of JoAnn Solov.)

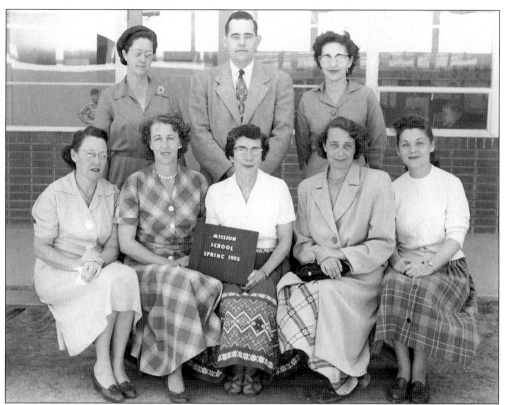

The women in the front row and the woman on the left of the top row (last names: Rudy, Sheldon, unknown, Vertrees-Kelley, Bryants, and Rudisill) constitute the original faculty at Mission Avenue School. Joe McNett is the principal and Florence E. Rudig, on the top right, served as the original school secretary and retained that position until her retirement. (Courtesy of Florence Rudig.)

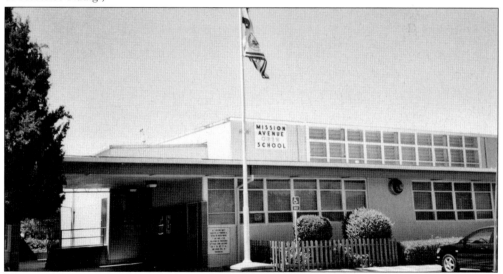

Mission Avenue School hasn't changed much from the look of this contemporary picture, but it now has 18 classrooms and 426 students. (Courtesy of Kay Muther.)

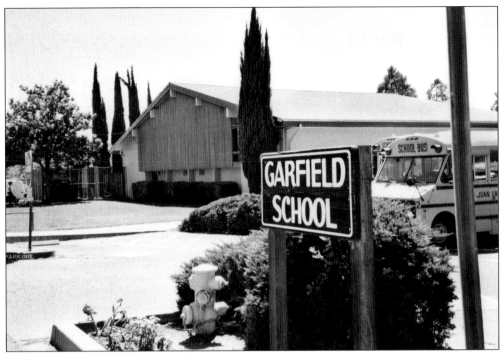

Garfield Elementary School was also constructed in 1953 to ease pressure on Carmichael School. It now has 23 classrooms and 465 students. (Courtesy of Kay Muther.)

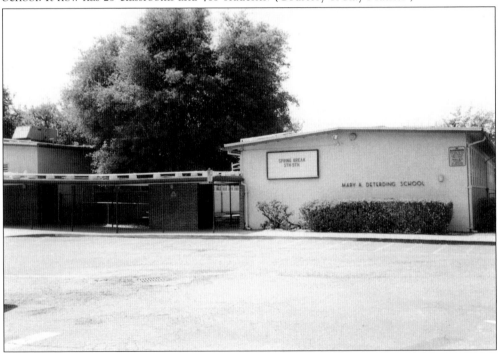

Mary A. Deterding Elementary School, named for one of the earliest settlers of the Carmichael Colony area, was built in 1954. It now has 23 classrooms and 534 students and is designated as a charter school. (Courtesy of Kay Muther.)

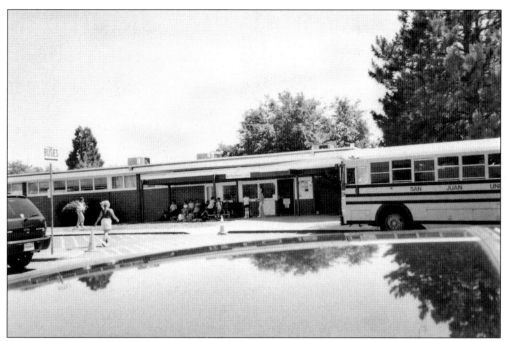

Starr King Elementary School, built in 1956, is one of the smaller schools in Carmichael. Serving only kindergarten through fifth grade, Starr King has 14 classrooms and 302 students. (Courtesy of Kay Muther.)

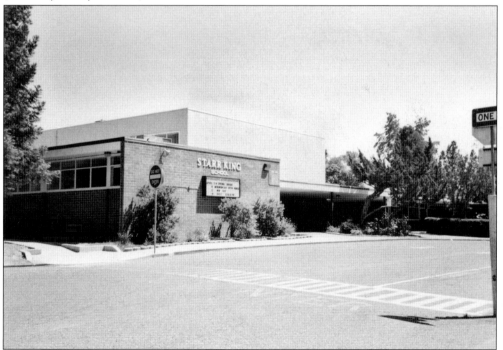

Starr King Middle School, which shares the campus of Starr King Elementary, was also built in 1956. Grades six through eight are taught here with 496 students in attendance. (Courtesy of Kay Muther.)

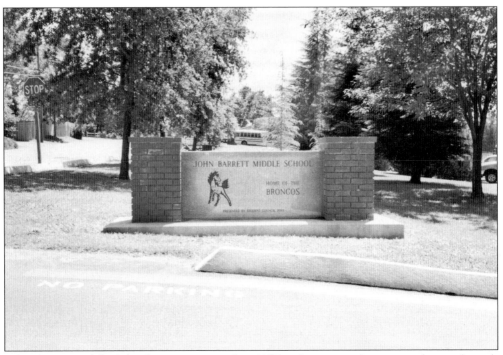

John Barrett Middle School was constructed in 1957 and serves students in grades six through eight. Current enrollment is 956 students. (Courtesy of Kay Muther.)

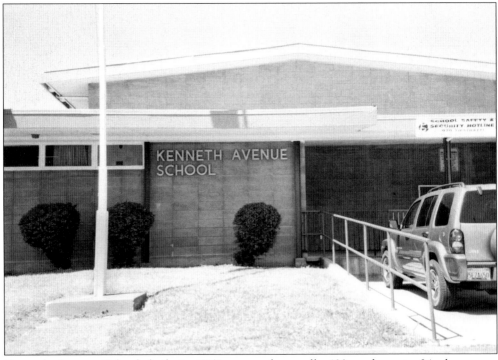

Kenneth Avenue School, built in 1959, currently enrolls 499 students in 24 classrooms. (Courtesy of Kay Muther.)

The early 1960s saw the completion of several schools in the Carmichael area. The first elementary school during that time was Thomas Kelly, completed in 1960 with 18 classrooms. The school now enrolls 398 students. (Courtesy of Kay Muther.)

Albert Schweitzer Elementary School, completed in 1961, now serves 444 students in 23 classrooms. (Courtesy of Kay Muther.)

Charles Peck Elementary School on Rutland Drive was built in 1962 and now has 469 students in 20 classrooms. (Courtesy of Kay Muther.)

Coyle Avenue Elementary School is one of two schools built in 1963. This school, the farthest north in the district, has 416 students. (Courtesy of Kay Muther.)

Del Dayo is the other elementary school constructed in 1963. Currently 463 students attend Del Dayo. (Courtesy of Kay Muther.)

Cameron Ranch Elementary School is the newest elementary school in Carmichael and is one of two schools constructed in 1964. There are 384 students and 18 classrooms. (Courtesy of Kay Muther.)

The second school built in 1964 was Winston Churchill Middle School. The largest of Carmichael's middle schools, Churchill has 967 students in grades six through eight. (Courtesy of Kay Muther.)

Del Campo High School is the closest thing there is to a Carmichael high school. Although technically in Fair Oaks, according to the post office, Del Campo is surrounded on three sides by Carmichael and is considered to be the local high school. About 1,885 students attend Del Campo. (Courtesy of Kay Muther.)

Six

RECREATION AND
COMMUNITY LIFE

Carmichael has always had a strong sense of community. When new folks moved in, they were welcomed. When trouble struck, someone would help out. When something needed doing, the community formed a group to address the problem. The Carmichael Irrigation District, the Carmichael Improvement Club, the Fire Protection District, even the Carmichael Elementary School and the Carmichael Community (now Presbyterian) Church were the result of community effort.

In addition to community work, there was a lot of community fun. Swimming in the American River was a top activity for school-age kids, but there was also fishing, baseball, parks, picnics, horseback riding, roller skating, bicycle riding . . . lots of fun things to do in Carmichael. As Dan Donovan, honorary mayor of Carmichael and volunteer fire chief for many years, said, "We live in the best place on earth." A lot of people still feel that way.

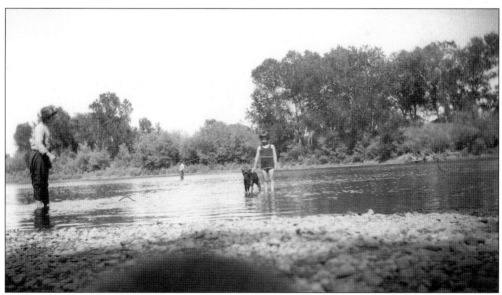

Doris Graves and her dog enjoy wading in the American River. Other folks remember the river activities, too. Roberta Gibbons Oldham tells of swimming across the river while holding hot dogs aloft, aiming for the picnic grounds on the other side. (Courtesy of Doris Graves Chez.)

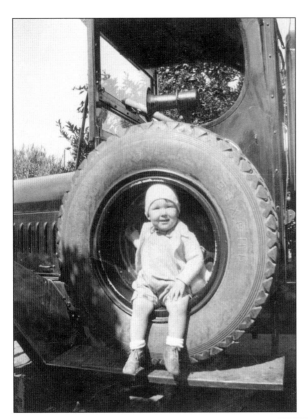

Fun is where you find it. A.L. "Red" Hughes thought it was fun to climb around on daddy's oil truck and sit in the tire in 1932. (Courtesy of A.L. "Red" Hughes.)

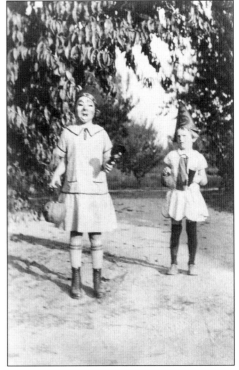

Halloween pranks aren't all that new. Dorothy Dickson and her cousin Idell Dickson go trick-or-treating in 1926. (Courtesy of Dorothy Dickson St. John.)

Some day trips combined education with fun. Elsie Hartman is shown here lounging on the lawn after visiting the state capitol building and grounds in 1916. (Courtesy of Doris Graves Chez.)

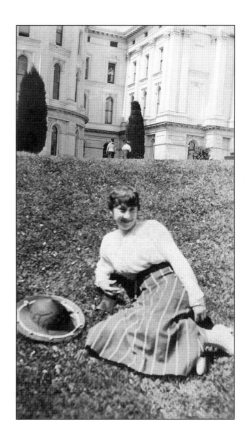

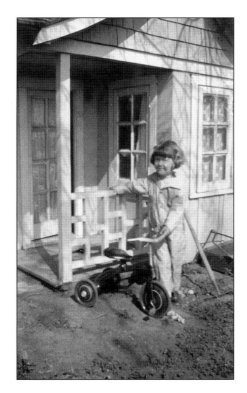

A variety of transportation modes were available to children in Carmichael. Doris Graves, age 20 months, reveals some of them: her tricycle . . .

. . . and her little soap box derby . . .

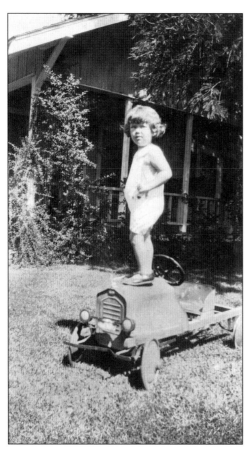

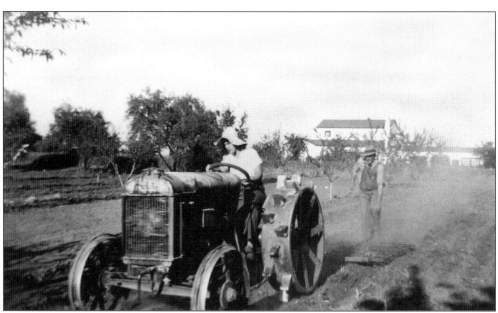

. . . and her dad's tractor several years later. (Courtesy of Doris Graves Chez.)

Idell Dickson (back of group) shows off the family flower garden to her brother Don and her cousins, the Baker boys. (Courtesy of Idell Dickson King.)

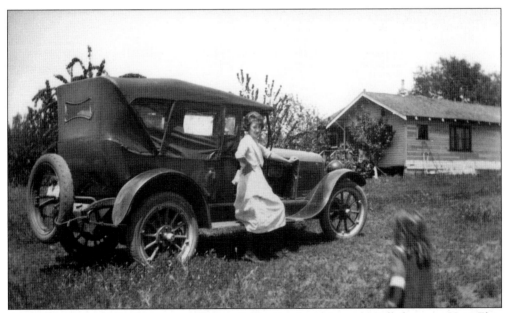

As soon as automobiles became readily available, Sunday drives were all the rage. Here Elsie Hartman Graves rests against her touring car. In the background is the house at Kenneth and Fair Oaks Boulevard that had been picked up and moved to that location. (Courtesy of Doris Graves Chez.)

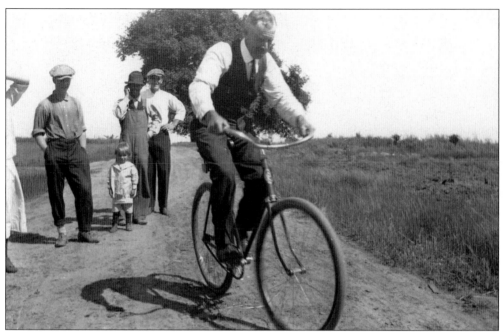

Fred Graves rides his bicycle on Kenneth Avenue as his sons Bernard and Bayard, a grandson, and others watch, c. 1917. (Courtesy of Doris Graves Chez.)

Doris Graves is shown with yet another mode of transportation, this time on four legs. Here she rides her horse Blue Bell through the peach orchard in 1945. (Courtesy of Doris Graves Chez.)

As with teenagers in every era, hanging out was a popular pastime. Dorothy Dickson and Thelma McKeown show how it was done in 1933. (Courtesy of Dorothy Dickson St. John.)

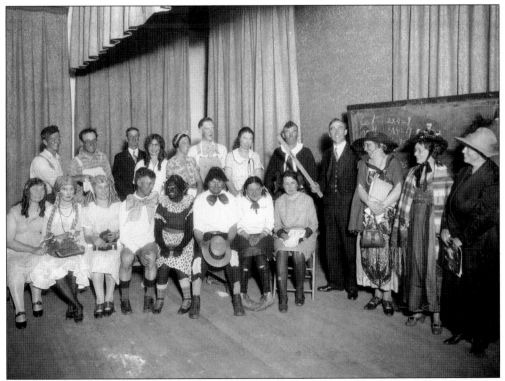

If entertainment wasn't brought to you, you had to make your own. This photo shows the cast of a skit performed for the Carmichael Improvement Club in the mid-1920s. It was probably performed on the stage of Carmichael Elementary School. (Courtesy of Carolynn Petersen.)

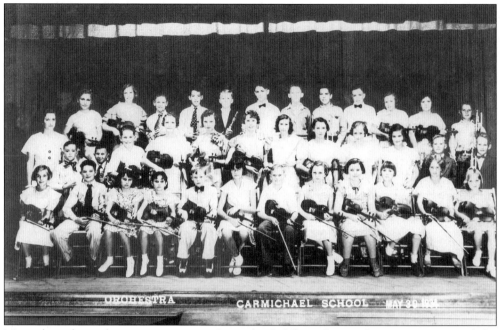

Music has always been important to Carmichael folks. This is the 1934 version of the Carmichael Elementary School orchestra. (Courtesy of Evans "Red" Clark.)

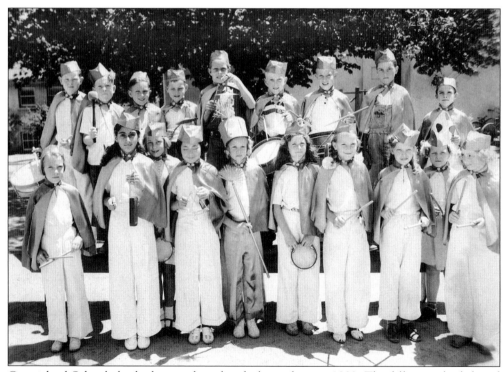

Carmichael School also had a marching band, shown here c. 1939. The fellow at the left end of the top row, "Red" Hughes, provided this picture. (Courtesy of A.L. "Red" Hughes.)

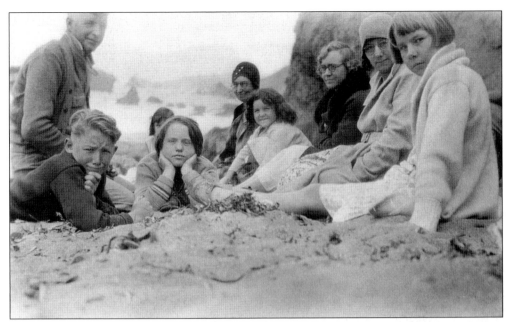

James Dickson took a bunch
to the beach, probably at
Bodega Bay, for a pleasant
afternoon. (Courtesy of Betty
Gibbons Schei.)

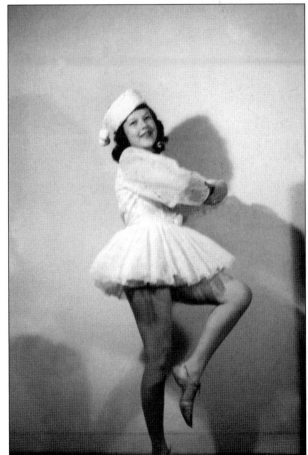

Virginia McGuirk, an enthusiastic
dancer, is shown here in costume
in 1936. She studied tap, modern,
and ballet dancing. (Courtesy of
Irene McGuirk Hannum.)

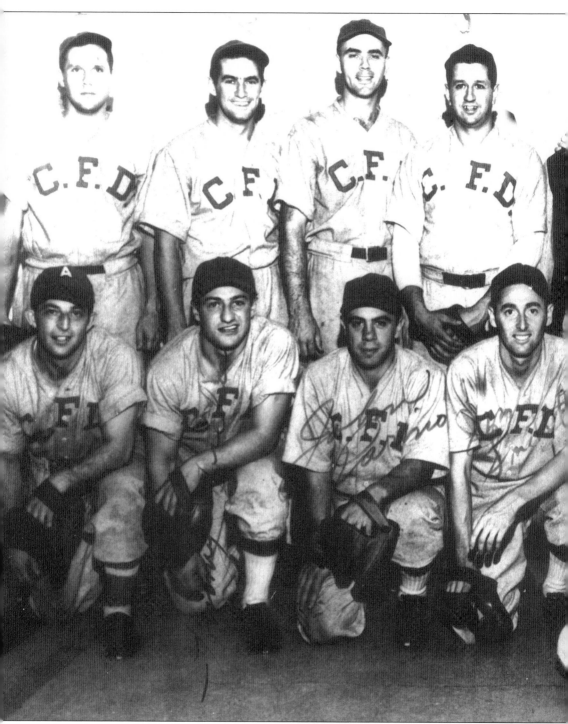

According to the *Sacramento Bee*, August 29, 1946, this team was the "most amazing team ever to perform in this league." The Carmichael Firemen won the state semi-pro championship and went on to win upset victories in the national championship. The Most Valuable Player of the national tournament was pitcher/slugger Loren Lollis, the first black player since Satchel Paige

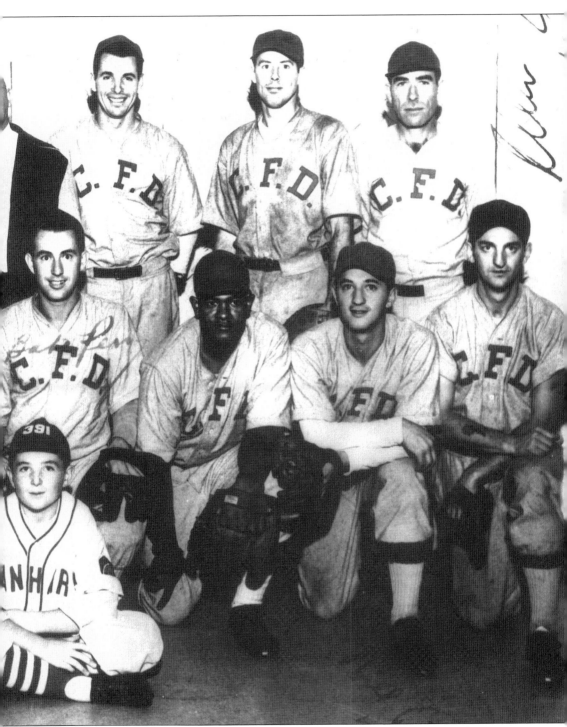

(MVP in 1935) to be so honored. The Firemen then went on to win the international semi-pro champ... championship over the Windsor, Ontario, Canadians to become world champs. They won three games out of four played, with the score in the first game 25-12! Sponsor Dan Donovan said this team "really put Carmichael on the map." (Courtesy of Joe Duarte.)

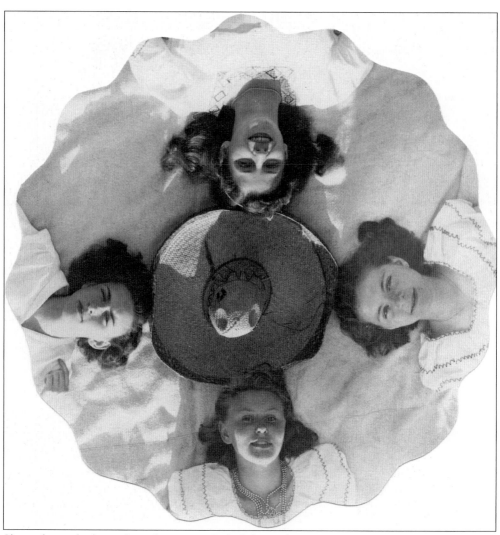

Shown here, clockwise from the top, are Dale Schwenck, Joan Durfee, Phyllis Keever, and Mary Dougherty resting around a Mexican hat after performing the famous dance of the same name for a fundraiser for the Carmichael Community Church in 1946. (Courtesy of Carmichael Presbyterian Church.)

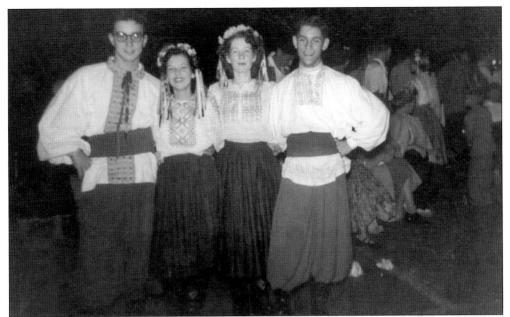

Serguey Kondratieff, Virginia McGuirk, Mary Dotson, and Fred Thrasher belonged to the Bar-None Folk Dance Club. This photo of the dancers in native costume was taken at an exhibition dance at Arden Town in 1950. (Courtesy of Irene McGuirk Hannum.)

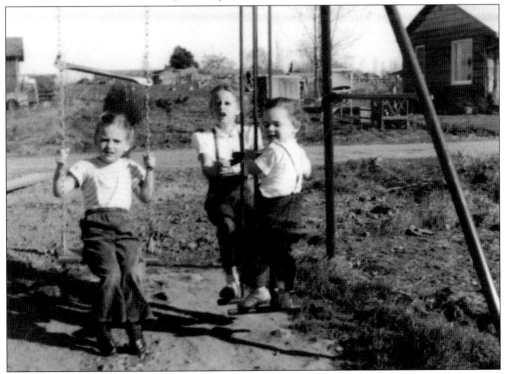

Shown playing on the swings in their yard in 1952 are, from left to right, Susan, Judy, and Peggy de Vriend. Unpaved California Avenue, near the Jan Drive intersection, is in the background in 1952. (Courtesy of Twila de Vriend.)

In an example of community spirit, the residents of newly constructed Mapel Grove get together in 1954 for an Easter egg hunt. (Courtesy of Dorothy Mapel Owens.)

Yet another mode of transportation is this donkey cart, driven by Thea and Bill Howard in 1956. (Courtesy of Claudia Howard.)

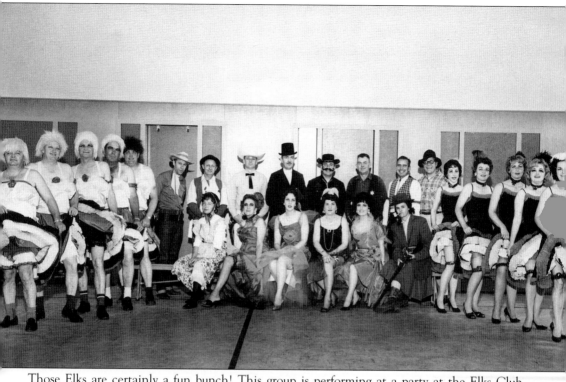

Those Elks are certainly a fun bunch! This group is performing at a party at the Elks Club sometime in the mid-1950s. (Courtesy of Carmichael Elks Club.)

All dressed up and ready for their musical performance in 1955 are, from left to right, Buzzy Giles, Douglas Gingerich, Jerrie Lee Houseworth, Pat Morrow, and Peggy Dunn. (Courtesy of Carmichael Chamber of Commerce.)

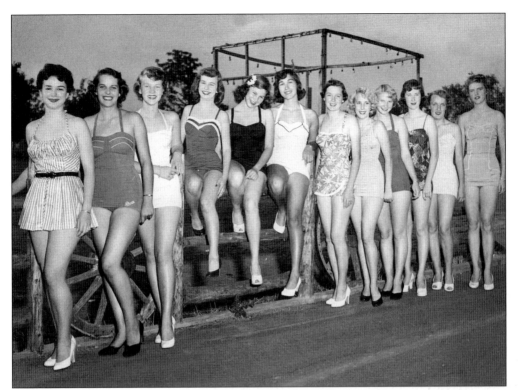

Dressed for the swimsuit competition in the Miss Carmichael pageant around 1955, these lovely bathing beauties are, from left to right, Mary Jane Bacchi, Harlene Kloss, Sally Mehren, Dolores Shatto, Winifred Carleton, Joann Becker, Jackie Armstrong, Jeanne Herzog, Joe Ann Gray, Mary Lewis, Alice Moore, and Dixie Jansesn. (Courtesy of Carmichael Chamber of Commerce.)

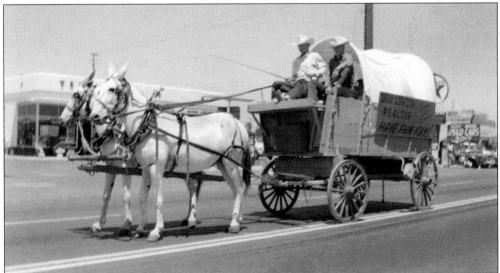

The Carmichael Elks Club has sponsored a parade for the Fourth of July for over 50 years. This fine pair of white mules pulls a covered wagon in the 1957 parade. (Courtesy of Carmichael Elks Club.)

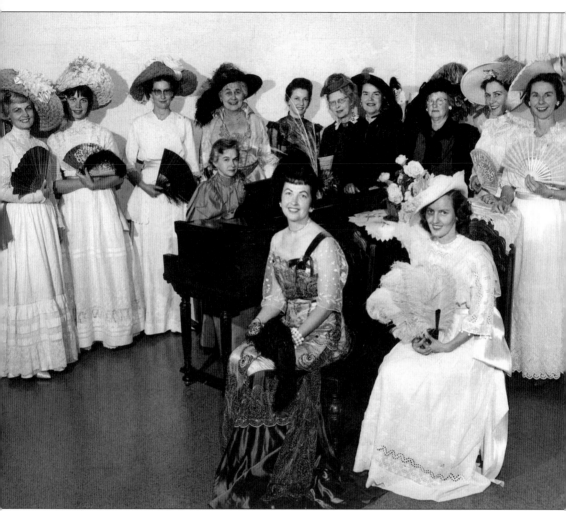

Dressed in period costumes for a fund-raiser are, from left to right, (standing) Louise Mapel, Linda Morrison, Roberta Wehmeyer, Winnone Mapel, Louise Kinzel, Elsie Kelly, Hermilla Taylor, Maude Grimshaw, Ardeen Kennedy Woods, and Betty Gibbons McCurry (now Schei); Ruth Davis (seated at the piano); and Carolyn Thome and Millie Wick (seated in front). Their goal was to furnish the parlor at the Carmichael Presbyterian Church. (Courtesy of Carmichael Presbyterian Church.)

Effie Yeaw, a noted environmentalist and naturalist, shows a group of children a little bird perched on a stick. Her son Galen reports that their home was often filled with birds. People knew she loved them and would bring injured or sick ones to her for care. (Courtesy of Effie Yeaw Nature Center.)

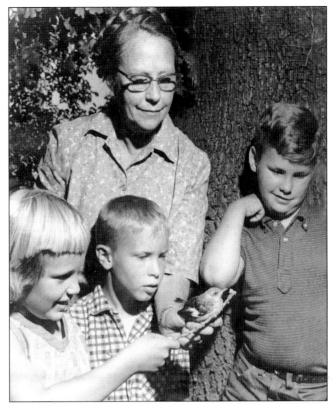

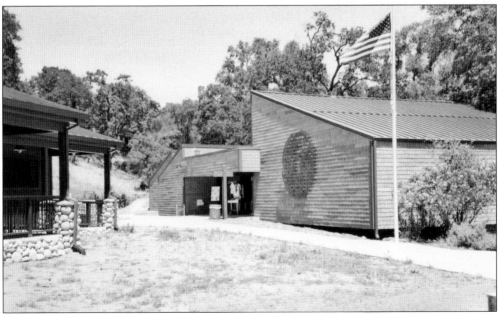

Effie Yeaw conducted day-long excursions in the Deterding Woods to teach children about the animals and plants of the region. Yeaw's contributions to nature have been recognized with the creation of the Effie Yeaw Interpretive Nature Center in Ancil Hoffman Park, officially dedicated on June 19, 1976, six years after her death. (Courtesy of Kay Muther.)

Another community club in Carmichael was the Seniors in Retirement. Here is Carl Hencken (right) being named "Big Sir" of that club. (Courtesy of Sharon Hencken Cheatham.)

And you thought it never snowed in Carmichael! Unusual as it was, this winter storm in 1962 allowed Sarah and Scott Howard to play in the snow. (Courtesy of Claudia Howard.)

Little boys everywhere love baseball and Carmichael is no exception. Jerry Hencken (far left) coached a Little League team in the 1970s. (Courtesy of Sharon Hencken Cheatham.)

Christine Pefley, whose family goes back to the 1920s in Carmichael, was crowned "Miss Carmichael" in 1975. (Courtesy of Jack Pefley.)

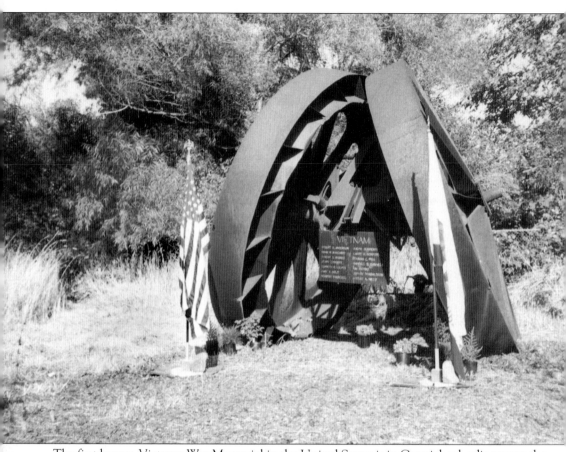

The first known Vietnam War Memorial in the United States is in Carmichael, adjacent to the La Sierra Community Center. Dedicated in 1973, it honors 14 students from La Sierra High School who gave their lives serving our country in Vietnam. The honored dead are Robert D. Anderson, Mark W. Burchard, Robert S. Byrnes, Jerry Cowsert, Kenneth R. Escott, Gary R. Field, Herbert Frenzell, Ralph Guarienti, Larry H. Morford, Thomas C. Pigg, Randall B. Rainville, Kim Richins, Jeffry Tharaldson, and Robert A. Willis. (Courtesy of Linda Jones.)

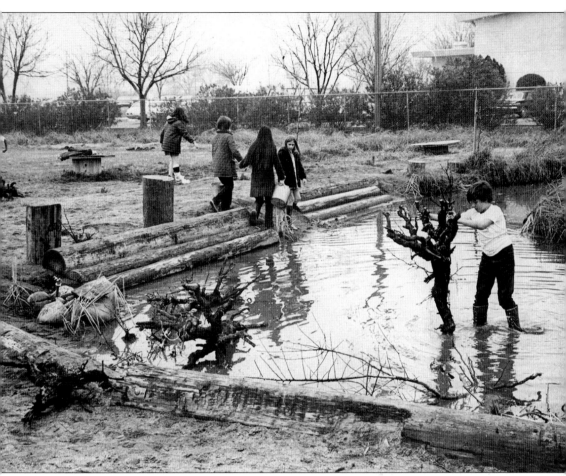

The Carmichael Vietnam War Memorial is in the Earl J. Koobs Nature Study Area, which is on land purchased by students from La Sierra High School and Garfield Elementary School in 1971. It was dedicated to Earl J. Koobs to honor his commitment to science and nature. This picture demonstrates the enthusiasm of Garfield Elementary School students including, from left to right, Elizabeth Ybarra, Barbara Griswold, Colleen Martin, Lynne DeLeon, Trecia Nienow, and Tim Larson pitching in to get the pond developed in April 1971. (Courtesy of Linda Jones.)

Earl J. Koobs, more widely known as Ranger Jack, was a biology teacher and naturalist at La Sierra High School and Garfield Elementary School. He was the inspiration and driving force behind the nature center named for him. The nature center is located adjacent to the La Sierra Community Center, previously the high school. (Courtesy of Linda Jones.)

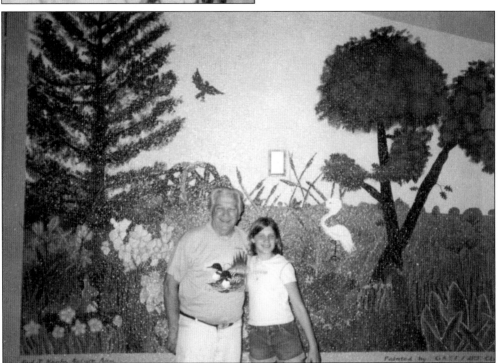

Ranger Jack stands with Garfield student Kelsey Jones in front of a mural painted by students in the school under the direction of art instructor Gil Peterson and artist-in-school Helen Plenert Horiuchi. The mural, which was dedicated in 2001, and the nature center it depicts are examples of the community spirit that has always enlivened Carmichael. (Courtesy of Linda Jones.)

Horseback riding was still possible within the confines of Carmichael proper in the late 1970s as demonstrated by Claudia Howard. (Courtesy of Claudia Howard.)

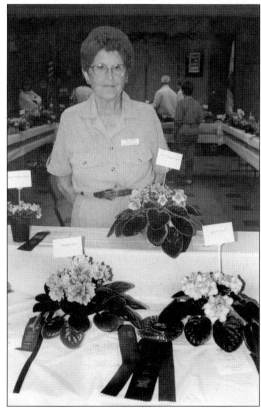

Twila de Vriend, a longtime African-violet enthusiast, was rewarded in 1993 with blue ribbons and "Best of Class" honors in the California African violet competition. (Courtesy of Twila de Vriend.)

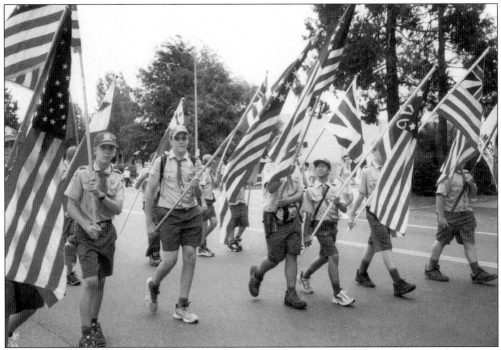

What would a Fourth of July parade be without a Boy Scout troop? These scouts carried the flags in the 1994 Elks Club parade. (Courtesy of Carmichael Elks Club.)

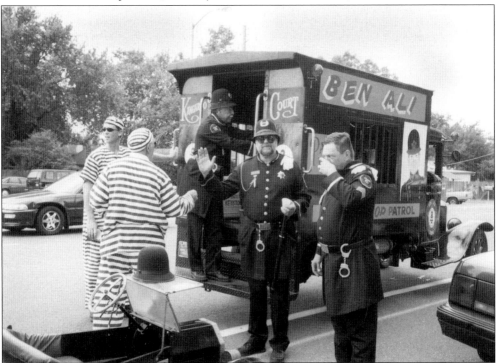

The Ben Ali Shriners play cops and robbers for the annual Elks Club Fourth of July parade. (Courtesy of Carmichael Elks Club.)

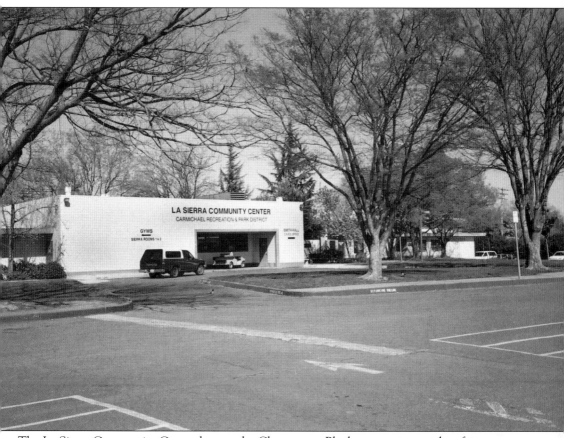

The La Sierra Community Center houses the Chautauqua Playhouse, an arts and crafts center, a basketball court, and other recreational opportunities. The facility was La Sierra High School from 1955 through 1980. (Courtesy of Kay Muther.)

Serving Carmichael since 1945, the Recreation and Park District consists of 16 park sites. Carmichael Park includes 38 acres located at the corner of Fair Oaks Boulevard and Grant Avenue. It has ball fields and the swimming pool shown here.

These tennis courts also belong to Carmichael Park. (Courtesy of Kay Muther.)

This fountain in Carmichael Park was built in 1982 to honor Bayard and Elsie Graves. Flanking the fountain, from left to right, are Doris Chez, Alison Chez, and Elsie Graves. (Courtesy of Doris Graves Chez.)

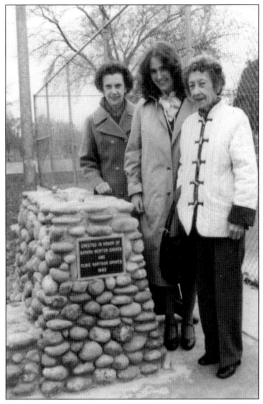

Another attractive park in the Recreation and Parks District is Del Campo Park. Lovely oak trees and a stream enhance a children's swing and climbing area. The park is located next to Del Campo High School with an entrance off St. James Street. (Courtesy of Kay Muther.)

REFERENCES

Cowan, James R. *A History of the Carmichael School and Community, 1880 to 1960.* Sacramento: Self-published, 1993.

Heritage of Faith: A 75-year History of Carmichael Presbyterian Church. Sponsored by the Heritage Committee. Carmichael: Carmichael Presbyterian Church, 1998.

Holewinski, Ruth, ed. *Our Lady of the Assumption 50th Anniversary, 1950–2000.* Carmichael: Our Lady of the Assumption Church, 2000.

Winterstein, H.E. "Carmichael's Mary Deterding, Founder's Day." Mimeograph. Carmichael: Carmichael School, 1966.